In the South of France

❧

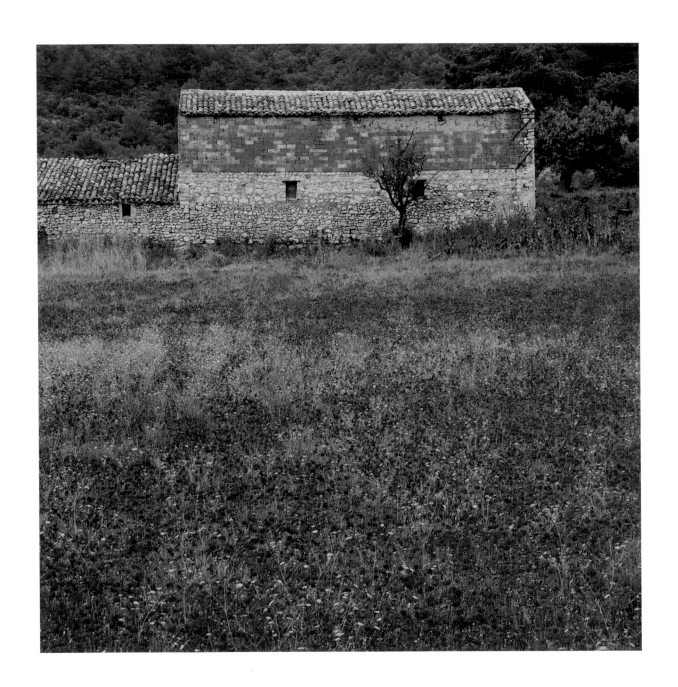

In the South of France

PHOTOGRAPHS AND TEXT BY

Don Krohn

AN IMAGO MUNDI BOOK

David R Godine · Publisher

Boston

This is an Imago Mundi book
first published in 1999 by
DAVID R. GODINE, PUBLISHER, INC.
Box 450
Jaffrey, New Hampshire 03452
website: www.godine.com

Library of Congress Cataloging-in-Publication Data
Krohn, Don.
In the south of France / photographs and text by Don Krohn. — 1st ed.
p. cm. — (Imago mundi book)
1. Provence (France) Pictorial works. 2. Photography, Artistic.
I. Title. II. Series.
DC611.P958K76 1999
944´.9—DC21 99-25662
CIP

ISBN: 1-56792-099-3 (hardcover)

FIRST EDITION

This book was printed in Hong Kong on acid-free paper by the C & C Offset Printing Company Ltd.

FOR JANIS, THEA, AND ZOË

"On ne voit bien qu'avec le cœur."

All the beauty of this Provençal countryside is born of the sun; it lives by light.

ALPHONSE DAUDET

Here, under a stronger sun, I have found what Pissarro said confirmed, and also what Gauguin wrote to me, the simplicity, the fading of the colors, the gravity of great sunlight effects. You never come near to suspecting it in the North.

VINCENT VAN GOGH

Is it any better in Heaven, my friend Ford, than you found it in Provence?

WILLIAM CARLOS WILLIAMS

O for a beaker full of the warm South...

JOHN KEATS

Contents

❦

A Different Light

A Different Light

THE NIGHT FLIGHT over the Atlantic to Paris is a magical passage. Six miles above the dark water, distant from any land, a transformative spell begins during the abbreviated night. By sometime the next morning, after reading a copy of *Le Monde* over a breakfast of croissants and *café au lait* at the airport, followed by a customarily exhilarating taxi ride into the city, one senses that the magic is complete, and in a pleasant tiredness all the world beyond France becomes pale and remote, a mere illusion.

The trip to the South on the TGV (*train à grande vitesse*) continues the enchantment, the train leaving from the Gare de Lyon and soon speeding at 170 miles per hour deep into the country, sailing into seas of yellow flowers, through orchards, pastures, and grain fields; and then on to the fabled ancient realm of Burgundy with its spired towns scattered among rolling fairy-tale hills, and its vineyards, with grapevines roasting in the sun on rocky slopes. Some of these small vineyards represent the true elite among wines, with famously resonant names like Le Chambertin, Clos de Vougeot, Romanée-Conti: bottled satin and velvet, according to a famous description.

The route continues on through other exquisite landscapes, flying past as if in a dream. Finally the river appears, the great Rhône. This is the beginning of the South of France, when the stately wide Rhône comes into view. As Ford Madox Ford wrote:

> Somewhere between Vienne and Valence the South begins; somewhere between Valence and Montélimar... Eden! The Rhône, having those towns on her banks runs due South from Lyons to the Mediterranean. And nothing will persuade me to believe that when

Man in contagious madness left those regions for the North that was not the real Fall and that what Eve ate sinfully was, not an apple, but a dish of Brussels sprouts boiled in water that lacked the salt of the Mediterranean. Let that at least serve for a symbol.

Here begins the land of van Gogh and Cézanne, of Giono and Daudet and Durrell, the vast province of pure, brilliant light and deep color, the luminous vistas and intimate places that have captured people's imaginations for centuries. If Thoreau had dwelled in France, this is where he would surely have come to live his life "deliberately" and to search for the true spirituality which the world had abandoned. Somewhere in this place, perhaps in a shepherd's hut in the high mountains, he would have taken up residence, planting his garden in a clearing among wild herbs.

People come to the South of France for its serene loveliness, but this has not always been a peaceful place. During the Wars of Religion, the price paid for adhering to one's beliefs was high, and it is shocking, even by the harsh standards of more recent times, to read of the murderous destruction of entire towns. In fact, underneath the rural calm, this has been a domain of principle. During World War II, the Resistance was very active in Languedoc and Provence, especially among the mountains, gorges, and caves of the Hérault region, and in the Cévennes mountains, and farther east, in the Vaucluse and the Provençal Alps.

Across the centuries, the peace here has frequently been violated by invaders, by the brutality of numerous trespassers. Lawrence Durrell made the following observation:

> From the purely historical point of view, what seems remarkable is the long tally of violence and drama which characterizes this land of green glades and noble forests, a minor paradise if ever there was one. Yet Goths, Franks, Vandals, Saracens, every variety of invader seems to have subjected it to the extremes of pillage, destruction, naked war. It was as if its beauty was too much for them, they went berserk. They trampled underfoot what they could not bear.

The historical aura is omnipresent here, the awareness not only of the distant past of Greek and Roman occupations, but also of the more recent past, evidenced often by small plaques, or occasionally revealed in personal encounters. Near the town of La Tour d'Aigues, below the imposing gray and green flank of the Lubéron Mountain, an American airman was shot down during World War II. He was helped from the plane and aided by nearby farmers, but he later died of his injuries and was buried in the local cemetery. Many years later, relatives came to bring his remains home to the United States, and the event was commemorated with solemn honor. This elegy was recently recounted to me by one of the rescuers, now an elderly gentleman, as he pointed across the road from his cherry orchard to the place where the aircraft had come down. The two of us stood respectfully for a long moment and looked at the tranquil spot, a bright field where some new vines were taking root, he remembering, and I imagining, a very different time. There, deep in Provence, in the breezeless heat and perfect quiet of midday, the sense of calm was overwhelming.

❦

IT HAD BEEN with some thought of van Gogh, who a century earlier had journeyed to Provence, "wishing to see a different light," that I went to live in the South of France. My destination was an old town located in the foothills of the Cévennes near the Hérault River, *un village perché,* which means exactly that—a village perched on a steep hillside. The advertisement had intrigued me with its utter succinctness: "Southern France: sixteenth century house, grand views." The population of the hamlet was thirty-four, although the number had once been somewhat higher, before the paper mill in the lower village closed, and while the local silk industry was flourishing. The house was beautiful, the kind of place I thought only existed in my imagination. The breathtaking setting reminded me of Hemingway's romantic description, from the famously elegant opening sentence of *A Farewell to Arms,*

of "a house in a village which looked across the river and the plain to the mountains."

The house was one of the largest buildings in the village, built of stone walls thirty inches thick, with dark wooden doors, a lovely covered terrace, a red tile roof, a huge fireplace, and a high studio room with—indeed—grand views. And there was a mysterious cellar (*la cave*), its arched entry hidden under the terrace, excellent for storing quantities of local wine, the liquid sunlight of the South. It was assumed that the house long ago had belonged to the mayor of the town; this fact had been inferred primarily from the seemingly small detail of several iron rings on an outside wall, for tying up horses. Higher up in the town, quite literally built into the ragged outcropping, was the *château*, older than our ancient house by a mere four centuries. It was a genuine castle by any definition, complete with turreted battlements, imposing walls with massive entry gates, and bell towers with flags flying on iron spires.

All through France, and especially in the mountains of the South, these medieval villages, some prospering and others in ruins, appear on hillsides, spilling down steep slopes. The structures of such towns have developed over a long history, and have been organized both by design and improvisation, in relation to the unique topography and particular style of planning of each place. The results resemble a huge installation, spread across a large territory, of monumental cubist sculptures. Yet these hill villages are so integrated into the scenery as to seem almost to be natural features growing out of the land, perhaps to be appreciated as just one more notable aspect of a highly unusual—and at times truly bizarre—geography, which also includes the most dramatic gorges and rock formations, and vast and complex caves and chasms. At the top of these communities, a church or castle usually commands the highest place. Especially in the more remote of these fastnesses, the deep silence and sense of timelessness can be astonishing. A settlement in these high elevations can seem almost Himalayan, suggesting perhaps an allegiance not to the polity of France, but to some secret federation of distant high mountain refuges, spiritual redoubts in the modern world.

It did not take long to become accustomed to life in the South of France. My daughters were welcomed in the small local school—*"Ah, les Américaines!"* was the enthusiastic greeting of the *maîtresse*—with a graciousness which I will always remember. From the fine adventure the children had at L'Ecole St-Joseph, I learned quickly to reject the stereotype of the French as anti-American; at least in the provinces, it simply does not apply. I enjoyed being gently influenced by the texture of rural French life: shopping at the local outdoor markets, making friends in the village, exploring the countryside and other towns, adopting a favorite café. After a rather long initial spell of cold and very rainy weather—*"Pas normal,"* I was constantly reassured—the famously sunny days did materialize, and I began enjoying the light I had come seeking. The brilliant days were balanced by the nighttime silence of the mountains. After dark, I would walk along the serpentine paths through the village, bats whirling around in splendid eeriness. During the night, the quiet was broken by the hourly bells from the church and the castle, and sometimes most amazingly by nightingales, or by immense thunderstorms which would come flashing majestically through the darkness across the hot plain from Provence.

As was the case in many houses in the Hérault region, ours contained a small fireplace whose purpose had been to incubate silkworm eggs. In fact the house had the name La Magnanerie, meaning "silkworm rearing-house," but apparently the name was rarely used. Silk production had been the major industry of the area, and a source of some fame, from at least the time of Louis XIV until well into the twentieth century, fully pervading most people's lives. The history of that epoch is much noted in the region. Economically, even now the area has not fully recovered from the end of that era, a commercial decline caused by the use of nylon and rayon in place of silk. In school, though now only for purposes of keeping alive the memory of Cévenol traditions, young children still raise silkworms in classrooms, watching them eagerly devour mulberry leaves, their favorite food. An older woman in the village described to me, gesturing and carefully enunciating, lest I would

think I had misunderstood her accented French, how women used to maintain the eggs' temperature with body heat, keeping them in the warmth of their bosoms, in a handkerchief tucked in *la poitrine*.

The windows of our old house, set deeply in the stone walls, were equipped with wooden shutters, quite substantial things, which we were instructed to close securely for the night. The whole village tightly sealed itself up like this each evening; a person wandering through would have found few obvious signs of life. No doubt this pattern was the continuation of a tradition dating back to less safe times, when the night was full of dangers real and imagined. And so nightly, having no wish to tamper with tradition and perhaps court danger, we closed and latched the shutters securely. And then each morning, the venerable house would stay perfectly dark, cool, and still until the ritual throwing open of the shutters let the warm brightness of the Midi pour in. Opening each window to the day, observing the angle of the sunshine coming in, I considered that for centuries in this house, at the same time of year, the sun's morning rays always had come through each of these windows in exactly the same way. I felt privileged to be able to sense so precisely, and without any alarm, the brevity of life, Milan Kundera's "lightness of being": something so transitory compared to the enduring stone of the village.

<div style="text-align:center">※</div>

TO EXPLORE THE South of France, it is best to travel with only the vaguest of itineraries, expecting to be guided through the day more by serendipity than according to plan. The one essential and thoroughly French tool, required to keep such an enterprise from being too disorganized a ramble, is one of the ubiquitous yellow-covered Michelin road maps. These maps, fine examples of the Cartesian devotion to order and organization, are an outstanding resource, elegantly showing roads and hamlets, as well as geographical features. To my

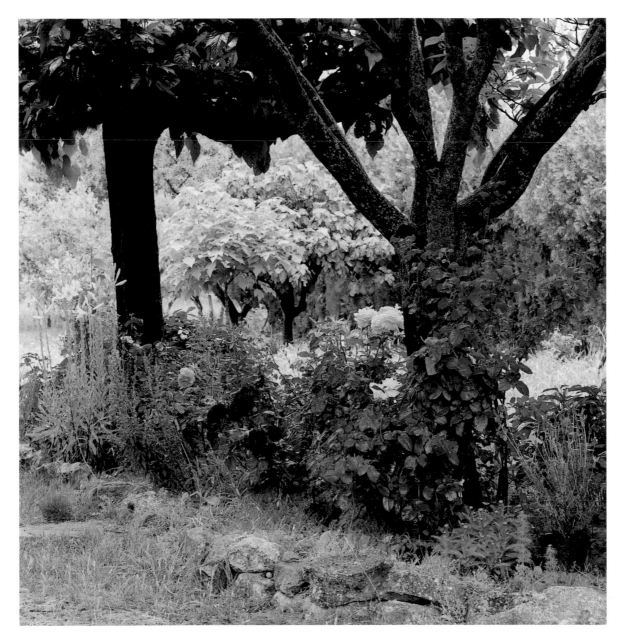

A WAYSIDE GARDEN IN LOURMARIN

knowledge, in the United States there is no equally detailed and accurate set of maps of a similar scale, and I am tempted to relate this fact both to the sense of anonymity in the American countryside, and to our lack of geographical literacy.

My preference was to set out before dawn, to be able to witness the sun giving life to the emerging landscape, and to watch villages slowly awakening. It is a daily renaissance, an extraordinary diurnal phenomenon which seldom is noticed. In the lovely spell of daybreak, I often thought of William Wordsworth's sweet early morning epiphany on Westminster Bridge in London: "Earth has not anything to show more fair." Dawn is the universal symbol of renewal, the world created once again. Traveling with a camera, I felt even more closely allied with each day's birth, for the evolving illumination would be essential to my endeavors. I would carefully study the changes in light through the hours, watching the day play itself out visually and dramatically.

From its earliest history, photography has been a proprietary French passion, and the South has been of interest to many great photographers (both from France and beyond) virtually from its invention to the present. I felt this background presence as I pursued my work. A camera brings me into closer contact with a place; it creates a bond, an association. In the South of France, it was integral to my explorations and experiences. I made France part of myself through my photographs, but there was nothing acquisitive in the process: photographing simply forced me to look carefully, to ask questions and try to understand the place in visual terms. I am not fond of the notion of *taking* a photograph: more properly stated, one *makes* a photograph. The French photographer Atget was aptly described by a friend as an *imagier,* a picture maker. The physical process of photography, after all, is a mere registering of reflected light for a brief moment; the entire event, truly, is more spiritual than mechanical, a method of paying homage and gaining understanding. Cameras existed for centuries before recording materials were invented: the ultimate production of a physical image was—and to me still is—an artifact of the visual experience. The photogra-

pher's primary goal is to master the camera's mystical power to find those exact points in space and time when the world becomes illuminated as if from within, when its sacredness is momentarily revealed.

The visual language of Southern France comprises certain repeated elements, the components of an old, mostly rural, panorama: lush fields and vineyards; the uncultivated upland *garrigue* of wild herbs, small flowers, and windblown trees; vibrant skies; ancient habitations built of honey-colored stone; neatly planted orchards; towns among hills or in the shadows of cliffs, or set in plains or along rivers, each with its café and church, and perhaps a square or a small park. Yet nothing seems repetitive. The individuality of each place, the newness of each vista, is always surprising. Perhaps this is because the clarity and sculpturing effect of the light here create a sense of heightened definition, and because people retain close identifications with particular places. There is no special quest for uniformity, no desire to obliterate the uniqueness of place: this quality is a central aspect of the appeal of the South of France, and being able to discover it for oneself is a privilege.

There is a reassuring certainty in the pattern of the days in the small villages, in the adherence to tradition. In cafés and small shops, commerce begins intently with the new day. The activity of the morning ends abruptly and promptly at lunch time, and in the quiet of early afternoon, which in warmer seasons is the deep heat of the day, shops close and the towns become deserted studies in tranquility. In late afternoon, activity resumes: people emerge, the cafés come back to life, and stores reopen. After the hours of closing, it feels almost like a second beginning to the day. The *boulangeries* and *pâtisseries* are usually among the busiest places in the afternoon, as people purchase breads and enticing desserts for the evening. There is a calming effect in this peaceful daily pattern; it provides an opportunity to establish a rhythm which connects to the life of the day itself. "The days are round," the Provençal writer Jean Giono observed.

Sundays have their own cycle: Mass in the local church—children and women dressed

quite colorfully, the men somewhat darkly outfitted and often standing in the back of the chapel—then a large midday repast at home, or an excursion somewhere *en famille.* On a major religious holiday, much of the village will attend church. In our little village there is a superb twelfth century Romanesque church set in the lower town's grassy park, a small and inviting building of nice proportion and unimposing scale. On Palm Sunday, it was remarkably affecting to see the gathering outside the church, each person holding a silver-green olive branch, the small crowd bathed in the gentle dappled shade and pale green light of the plane trees.

Beyond the villages, away from the life of cafés and markets and the nearly universal games of *boules* (more accurately called *pétanque*), one can explore on foot, penetrating deep into the landscape, finding there a pure solitude and hidden mystery. By setting off on a *balade,* one can experience the land in its greatest intimacy, following ancient footpaths into the mountains, or winding one's way through a valley in stunning quiet, smelling wild thyme or rosemary underfoot. This is *la France profonde,* literally "deep France": the timeless agrarian soul of the country, the place of farmers and shepherds. The historian Fernand Braudel correctly described this primordial domain as a place where one may hear "strange music, the sound of sheep bells, a dog barking, a man calling out commands, and the flock traveling past, gradually moving into the silence." He called this realm, which indeed exists today, "the time and space of yesterday."

Among many excursions, a most memorable journey by foot was a long walk over hills and into the lovely and wild valley of the Buèges, a classic Languedocian landscape just south of the Cévennes. The hike took all morning, and in early afternoon I arrived tired and somewhat weak with hunger at a small, locally famous *auberge,* the only establishment of any sort for miles around, just as the owners were finishing their lunch. Because of a bit of confusion in an earlier telephone call—always a risky way to communicate in a foreign language—I had not understood that this was their weekly closing day. With only a moment's

hesitation the proprietress, appreciating the situation, provided a private repast for me, and on the shaded terrace, protected from the formidable midday heat of the late southern spring, I dined most gratefully.

※

IN THE COURSE of all my wanderings, I elaborated a unique definition of the boundaries and qualities—a private map—of the South of France. Before discussing that, it is worth considering the various geographical terms applied to the region. The place names are inexact and confusing in no small measure, yet each of them brings some element of history to one's understanding of the area. Neither Provence nor Languedoc has any specific boundaries in modern France, as the old provinces were replaced by smaller *départements* in 1790. Provence may be considered as an area which is mostly east of the Rhône; it includes several departments, one of which is the Vaucluse—a place which for many people is the quintessence of Provence, a pure concentration of its ambiance. Yet the origin of the word Provence, the Latin *provincia* (meaning province), referred to the much larger area, stretching west as far as the Pyrénées, which once had been under Roman control. Languedoc is used to describe a certain area to the west of the Rhône, the word being derived from *langue d'oc,* referring to the old linguistic characteristic of using the word *oc,* rather than *oïl,* for "yes." The domain of the *oc* speakers, however, was considerable—far greater than the limited area we now refer to as Languedoc, and it certainly included the area east of the Rhône as well. And to confuse things further, the whole of the South, from Italy all the way west, past the Pyrénées and on to the Atlantic coast, is referred to as the Midi. Concerning this confusing terminology, to which we must add not only all the department names, but also the more recently established administrative *régions,* I have no desire to force any neat order. Instead—and I am not alone in this—I tend to use certain geographical

terms somewhat imprecisely, trying to reach for what seems to be the best label in any particular context.

Now I return to the specifics of my own map. It is merely a provisional definition of the South of France. For at some future time, if I am able to reexplore the region, to rediscover it, I will certainly redefine it for myself. For this endeavor, for this book and this series of photographs, I have followed a peripatetic and unpredictable muse. I set no fixed geographical agenda, having determined, in the words of the poet Theodore Roethke, to "learn by going where I have to go." If there were to be an order to my exploits, it would be directed by my accumulating experiences of the place, according to an emerging artistic plan.

In the end, the South of France I have focused on is an area of plains, hills, rivers, and mountains, extending about one hundred miles on each side of the Rhône; a territory of small towns and a few celebrated ancient cities; a place of woodlands, wildflower meadows, pastures, cultivated fields, and romantic scraggy wasteland *garrigue*. It is, most characteristically, an inland place, unquestionably influenced by the Mediterranean Sea in some aspects, but singularly distant from it. Mediterranean light infuses the air, and the signature of Mediterranean culture is here: this is indeed the land of the olive and the grape. But here the sea itself is always remote: an engine of weather and commerce, a key to the history and meaning of the South of France, yet often more rumor than fact. (A curious reminder of its proximity was this: awakening on several mornings deep in the mountains to find a yellow powder covering everything—sand blown across the sea from North Africa.) The coast remains fundamentally apart: there is the glorious Camargue, that great exotic swampy place, which feels somewhat like the American West, and which is more water than soil; there is the famous Côte d'Azur, a cosmopolitan phenomenon, a high profile international entity; and there is also Marseille, France's redoubtable second city and one of the world's great ports, certainly a place of no small distinction, but quite remote from the locations on my map. Being near the sea, one looks outward across the water, to disparate places. The

land near the coast feels almost incidental, a dearly loved but impermanent and threatened habitation from which to explore. If one lives by the sea, as I do most of the time, the center of gravity is somewhere off shore: there is always a force drawing one away from home. It became clear to me that the coastal areas were not on my map of the South of France; they were not part of the story I found myself telling, a story of unassuming, reserved, almost secret places.

In these inland plains and mountains, people look inward, anchored, as it were, to the soil; they revere it and understand it. In this South of France, people find sustenance and renewal in the earth, in their own localities. I was surprised when I realized that my dearest friends in the village had probably never been to Paris. Being courteous by nature, they listened politely to my discussion of a recent trip there, but seemed only faintly interested in it; they were always more concerned with local people and things. The deep conservatism of the region—not a political conservatism, particularly—is based on this interest in the indigenous, and on a concern with locality and with ancient ties, connections to another era, to a fabled yet tangible past. The South draws to itself people who sense the discontinuities of modern life, people who want to discover the connectedness of the rural elements of existence. It has been thus for a long time. In the middle of the nineteenth century, this impulse brought the writer Alphonse Daudet from Paris back to his native Provence, where he wrote his beguiling *Lettres de mon moulin* from a ruined windmill in Fontvielle, far from the stress and sophistication of Parisian life. Daudet loved the pleasures of rural life, the restoration of the senses, and he found in the South, in its rituals and loveliness, in its antediluvian resonances, a calming authenticity.

<div style="text-align:center">❧</div>

AMONG THE MANY DELIGHTS to be found in the South of France are the outdoor markets. They range in size from the most modest appearances of one or two farmers, setting up shop in

a village square once a week, operating out of the back of a truck, to the most elaborate and dazzling scenes of commerce imaginable, veritable encampments of vendors established under canopies of plane trees in the centers of cities and larger towns throughout the region. The reputations, and certainly in some cases the geneses, of cities such as Apt, Cavaillon, or Ganges, involve their roles as market towns. The South of France has been shaped by its location on the ancient trade route which ran across Europe to the Mediterranean and on to Asia, and these markets claim some derivation from the periodic fairs, the earliest promising stirrings of modern commerce and communication, which were held along that route. Even now, centuries later, in the presence of vendors showing off the latest gas powered farm equipment, the faint and mysterious echo of those distant centuries persists.

Depending upon the town, the market may be a place to purchase clothes, shoes, tools, housewares, live animals, flowers, soaps, old books, toys, antiques, fabrics, plants, pottery, baskets, or farm supplies. But above all, a market is about food, especially local food. Here is the place to experience the abundance of the region, to fill a basket by choosing among dazzling varieties of olives, breads, cheeses, fruits and vegetables, sausages, honey, olive oil, wine, herbs, innumerable regional specialties, and anything else one can imagine consuming. The market is the grand connection to the sun-drenched land, which is still the ultimate strength and inspiriter of this place. Without this intercourse, the fields and orchards and vineyards, the *terroir,* as the French say, would for the visitor only be decoration, mere ornament, an indication of the presence of rural industry.

Taking nourishment from the land is no less than an act of communion. To spend a lovely morning at the market, and then to return home and be rewarded for this effort with a lunch on the shaded *terrasse* consisting of aged goat cheese, *olives du pays,* crusty *pain de campagne,* cherries, local wine, and—if one were nimble enough in marketing to have made it to a favorite stand in time—delicious Roquefort tart, is a ritual which one can learn to appreciate with very little effort. And it is even easier to enjoy this repast if the view out to

the vineyards on the nearby hills defines the word idyllic, with swallows flying great random patterns in a sky of pure cerulean.

THE SOUTH OF FRANCE has an allure which cannot be fully explained. The glowing scenery, the food, the climate, and the history and culture are evidently central to its charm. And yet there is a faint intimation of something else, some force at work far beyond the obvious. In the isolation of villages and the serenity of luxuriant fields, among the low stone farmhouses, in all the constant reminders of the passage of time and the immense scope and indifference of history, there can at times be a kind of loneliness about this place. Durrell refers to "landscapes of an almost brutal serenity." Like the mistral, the region's strange and intense wind which can dramatically transform a calm day, there is a counterpoint to all the beauty and tranquility, a tension which, paradoxically, contributes to the complex allure of the area. The aura of the place is not a fixed thing, not an uncomplicated demonstration. Rather it is a challenge to the imagination. The mistral is in fact an excellent metaphor: the enervating blowing has its rewards, scrubbing the atmosphere to complete transparency, and leaving in its wake a hard deep blue sky. The loveliness of the South overwhelms in part because of its elegiac and sometimes dissonant harmonies. Its appeal to writers and artists over the centuries has been based more on the fascination with this enigmatic texture than on a simple attraction.

The list of painters who worked in the South of France is illustrious. Among many whose artistic identities are at least partly connected to the region are Courbet, Monticelli, Guigou, Renoir, Signac, Bonnard, Seyssaud, Matisse, Picasso, Chagall, Soutine, and de Staël. But without question, the two towering masters associated with the South are Cézanne, a native of Aix-en-Provence, and van Gogh. These two geniuses found their greatest challenge and

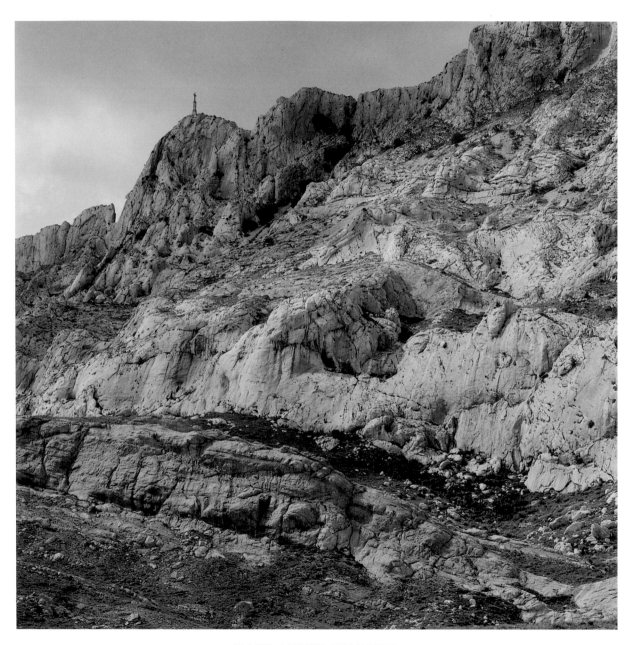

MONT SAINTE-VICTOIRE

inspiration in the forms and colors of Provence. They sensed the essential enigma at the heart of this strange place, the complicated visual messages of the atmosphere and light of the South of France. Becoming devoted to this landscape, they tried in their paintings to penetrate the mystery of what they saw. Their work in the South, the artistic record of their inquiries, ranks among the most significant painterly legacies.

Paul Cézanne, after returning from Paris, turned his attention to his surroundings in Provence. From his base at the Jas de Bouffan, a seventeenth century manor in Aix-en-Provence, he ventured out with paint and canvas, discovering in the pure and saturated colors, and in the elemental shapes of the land, a new and complex dispensation. The great modern exponent of Cézanne's genius, the critic Meyer Schapiro, saw in his achievement "the fusion of nature and self." One of Cézanne's most famous subjects was his beloved Mont Sainte-Victoire, near Aix; he produced more than sixty renditions of it. Schapiro brilliantly described one of the last of these paintings as "a stormy rhapsody in which earth, mountain, and sky are united in a common paean, an upsurge of color, of rich tones on a vast scale. It is an irrepressible lyric of fulfillment which reminds us of Beethoven's music."

Cézanne's artistic labors in the South, emphasizing geometry and color, produced a glorious body of work marked by fervid experimentation; it was probably the most free and expressive phase of a career which established the groundwork for the most comprehensive artistic revolution since the Renaissance. Cézanne's prescient description of his role was this: "I am the primitive of a new art." Writing in the *New York Times* of the 1996 Cézanne exhibition in Philadelphia, Michael Kimmelman summarized the dimensions of this influence: "It's a startling thought that Paul Cézanne, who was born in 1839, has had a more pervasive influence over the art of the 20th century than any painter born during in it. He has inspired the Fauves, the Cubists, the German Expressionists, the Russian Constructivists and Supremacists, the Surrealists, and virtually every serious painter since."

The other great adventure of painting in the South of France, that most astonishing and poignant story of genius and struggle, is that of Vincent van Gogh. Despite the short time he spent there, and in spite of the fact that he was not French, probably no person is as strongly associated with the region. In the course of two years spent first in Arles, and later at the asylum in St-Rémy-de-Provence, van Gogh created hundreds of paintings, watercolors, and drawings. He also wrote a considerable number of letters, many of them highly insightful examinations of Provence and of himself and his artistic conceptions. It is a staggering level of artistic production, yet the real source of amazement is the commanding stature of the works. It is a challenge to think of any group of paintings as wondrous as van Gogh's canvases from the South of France.

Looking at van Gogh's paintings from Provence, it seems as if his artistic development had simply been waiting for the chance to flower magnificently and joyously in the brilliance of the South. He looked out into the rural vistas, and at the faces of the people around him, and responded with paintings of heroic emotional force. His approach was to use his formidable artistic skills to develop a singular language of expression, finding in the strong light and vivid hues of the place the tools for creating a personal visual universe. Looking closely at any of his paintings from the South, one is struck by the flowing and powerful force of the design, and by the thick, almost sculptural application of paint: van Gogh was driven to record as authentically as possible a spiritual experience, this preternatural radiance of the South and his interaction with it. The place was his true inspiration, the scene of his ultimate achievement. His increasing psychological difficulties, and his tragic death soon after leaving Provence, added a sad coda to his great work there, augmenting the emotional turbulence of these already powerful expressions.

Van Gogh loved the clarity and graphic intensity of the South, and in his letters he obviously enjoyed describing in detail the pleasure and challenge of working in Provence:

Essentially the color is exquisite here. When the green leaves are fresh, it is a rich green, the like of which we seldom see in the North, quiet. When it gets scorched and dusty, it does not lose its beauty, for then the landscape gets tones of gold of various tints, green-gold, yellow-gold, pink-gold, and in the same way bronze, copper, in short starting from citron yellow all the way to a dull, dark yellow color like a heap of threshed corn, for instance. And this combined with the blue—from the deepest royal blue of the water to the blue of the forget-me-nots, cobalt, particularly clear, bright blue—green-blue and violet-blue.

Of course this calls up orange—a sunburned face gives the impression of orange. Furthermore, on account of the many yellow hues, violet gets a quick emphasis; a cane fence or a gray thatched roof or a dug-up field make a much more violet impression than at home. [June/July, 1888]

When we have mistral down here, however, it is the exact opposite of a sweet country, for the mistral sets one on edge. But what compensations, what compensations when there is a day without wind—what intensity of color, what pure air, what vibrant serenity. [September, 1888]

Both van Gogh and Cézanne were passionately committed to comprehending and recording their experiences of the South of France, and to finding the transcendent meaning of the radiant light of the Midi. The poet John Keats has stated clearly what many artists instinctively believe:

> When old age shall this generation waste,
> Thou shalt remain, in midst of other woe
> Than ours, a friend to man, to whom thou say'st,
> "Beauty is truth, truth beauty,"—that is all
> Ye know on earth, and all ye need to know.

Writers in the South of France

THE SOUTH OF FRANCE will always be associated with the writers who have lived and worked here. Western lyric poetry traces its roots directly to Southern France, to the fabled troubadours of the twelfth century. Singing first of courtly love, after the example of Count William, grandfather of Eleanor of Aquitaine, they later expanded their subject matter far beyond this literary convention. They wrote in Old Provençal, also called Occitan—the *langue d'oc*. Traveling from town to town, the troubadours brought influences of the mystical Islamic Sufis to their verse, most importantly the concept that truth is better comprehended and expressed in experience and poetry than in learned discourse. This understanding of the significance of verse ultimately became the organizing principle of the development of poetry in Europe, and it seems to resonate through the works of all the region's writers.

The suppression of the Provençal language, begun in 1539 with the Edict of Villers-Cotterêts, marked the beginning of an extended struggle for cultural autonomy and survival. The decree mandated the use of French as the official language in government, schools, and churches. In the nineteenth century Frédéric Mistral, the preeminent poet of Provence, launched a movement called the Félibrige to revive the old language and restore the cultural integrity of the region, associating himself at the same time with a renewal of the troubadour tradition.

In addition to natives like Mistral, the region has been the permanent or temporary home of many writers. When a writer travels to the South of France, the place itself has an ineluctable way of becoming an essential theme, enveloping other ideas. Perhaps the impulse for the writer to locate in the South had been the solitude, the pastoral spirit. Yet at

some point the place itself pushes other subject matter aside, demanding attention in its own right. Southern France is a land so bright and distinct, so immersed in its past and demonstrative of rustic passions, that a writer would find it difficult to ignore. Thus there exists a literature of the South of France, a loosely connected canon having, if any common denominator, only the desire to understand the secrets of the region. It is a spectacularly diverse and fascinating confederation, including at least the following names: Henri Bosco, Albert Camus, Jean Cocteau, Colette, Alphonse Daudet, Lawrence Durrell, M. F. K. Fisher, F. Scott Fitzgerald, Ford Madox Ford, André Gide, Jean Giono, Henry James, Thomas Jefferson, Rudyard Kipling, Katherine Mansfield, W. S. Merwin, Frédéric Mistral, Vladimir Nabokov, Marcel Pagnol, Petrarch, Ezra Pound, George Sand, Tobias Smollett, Gertrude Stein, Robert Louis Stevenson, Paul Valéry, Jules Verne, Peire Vidal, and Emile Zola.

To assist in telling the story of the delight of the South of France, the following passages are offered, excerpts from the works of four of these writers:

Lawrence Durrell, from the introduction to *Caesar's Vast Ghost:*

"Swerving down those long dusty roads among the olive groves, down the shimmering galleries of green leaf I came, diving from penumbra to penumbra of shadow, feeling that icy contrast of sun blaze and darkness under the ruffling planes, plunging like a river trout in rapids from one pool of shadows to the next, the shadows almost icy in comparison with the outer sunshine and hard metalled blue sky. So to come at last upon Valence where the shift of accent begins: the cuisine veers from cream to olive oil and spices in the more austere dietary of the south, with the first olives and mulberries and the tragic splash of flowering Judas, the brilliant violet brush stroke of unique Judas. Here, like the signature at the end of a score, the steady orchestral drizzle of cicadas: such strange sybilline music and such an exceptional biography, so scant of living-time, with so long underground in the dark earth before rising into the light! Anisette (pastis) everywhere declared itself as the ideal accompaniment for the evening meditations of the players of *boules;* no village square

in summer was without the clickety-click of the little steel balls, no shady village without its *boulistes* steeped in the Socratic austerity of the silence between throws. The holy silence of the *bouliste* is pregnant with futurity, his convulsions and contortions when things go wrong are pure early cinema; the immortality of Pagnol is based upon a careful study of the graphic originals available to him in a long lifetime of attending tournaments in town and hamlet alike."

Alphonse Daudet, in one of his *Lettres de mon moulin,* describing the transhumance, the still surviving semiannual migration of herds of sheep and goats:

"In Provence, when the warm weather comes, it is the custom to take the flocks up to the Alps. Beasts and men spend five or six months high up there, under the open sky, knee-deep in the grass. Then, with the first chill of autumn, they come down again to the farms to browse on the little grey hills, scented with rosemary. Well, yesterday evening, the flocks were returning. The farm entrance had been waiting wide open since morning for them; the pens had been strewn thick with fresh straw. As time passed people kept saying, 'Now they're at Eyguières, now at Paradou.' Then, all at once, towards evening, a great shout is heard: 'There they come!' and, far off in the distance, we see the flock approaching in a halo of dust. The very road itself seems to be on the march... The old rams lead the way, fierce-looking, their horns piercing the dusty air; behind them moves the main body of the sheep, the ewes a little weary, with their young trotting in their footsteps; the mules, with their red pompoms, follow carrying the day-old lambs in baskets which rock like cradles; then the dogs, dripping with sweat, their tongues almost touching the ground, and the shepherds, two great rascals in their home-spun russet cloaks which reach to their heels like ecclesiastical vestments.

"All of them file joyously past us and squeeze through the farm gateway, their feet pattering like a shower of rain... Inside you should see the commotion. From high up on their perches, the big, tulle-crested, green-and-gold peacocks have recognized the arrivals and

welcome them with tremendous trumpet-calls. The hens, asleep in the hen-house, awake with a start. All are up—pigeons, ducks, turkeys, guinea fowl. The farmyard seems to have gone mad; the hens talk of making a night of it! It is almost as if each sheep had brought back in its wool, along with the scent of the rough Alpine grass, a little of that keen mountain air which intoxicates you and sets your feet dancing.

"In the midst of all this commotion the flock reaches its quarters. The way the sheep settle-in is a delight to behold. The old rams are visibly moved on seeing their mangers again. The lambs, the very small ones, those who have been born on the journey and have never seen the farm, gaze round in wonder. But most moving of all to see are the dogs, those wonderful sheep dogs, thinking only of their charges, oblivious of everything else in the farm. The watch-dog calls to them in vain from inside his kennel; in vain the brimming bucket at the well beckons to them; they will see nothing, hear nothing, until their charges are all safely housed, until the big bolt is pushed home in the little wicket-gate, and the shepherds are seated at table in the lower room. Only then do they consent to make for their kennel, and there, while lapping their bowl of soup, they tell their farm friends all they did high up on the mountain, that dark grim place where there are wolves and great purple foxgloves brimful with dew."

Robert Louis Stevenson, in *Travels with a Donkey in the Cévennes,* describing the transcendental magic of a night spent in the open air:

"Night is a dead monotonous period under a roof; but in the open world it passes lightly, with its stars and dews and perfumes, and the hours are marked by changes in the face of Nature. What seems a kind of temporal death to people choked between walls and curtains, is only a light and living slumber to the man who sleeps afield. All night long he can hear Nature breathing deeply and freely; even as she takes her rest, she turns and smiles; and there is one stirring hour unknown to those who dwell in houses, when a wakeful influence goes abroad over the sleeping hemisphere, and all the outdoor world are on their feet. It is then

that the cock first crows, not this time to announce the dawn, but like a cheerful watchman speeding the course of night. Cattle awake on the meadows; sheep break their fast on dewy hillsides, and change to a new lair among the ferns; and houseless men, who have lain down with the fowls, open their dim eyes and behold the beauty of the night.

"At what inaudible summons, at what gentle touch of Nature, are all these sleepers thus recalled in the same hour to life? Do the stars rain down an influence, or do we share some thrill of mother earth below our resting bodies? Even shepherds and old country folk, who are the deepest read in these arcana, have not a guess as to the means or purpose of this nightly resurrection. Towards two in the morning they declare the thing takes place; and neither know nor inquire further. And at least it is a pleasant incident. We are disturbed in our slumber only, like the luxurious Montaigne, 'that we may the better and more sensibly relish it.' We have a moment to look upon the stars, and there is a special pleasure for some minds in the reflection that we share the impulse with all outdoor creatures in our neighborhood, that we have escaped out of the Bastille of civilization, and are become, for the time being, a mere kindly animal and a sheep of Nature's flock."

M. F. K. Fisher, from her book about Aix-en-Provence, *Map of Another Town*; the last paragraphs of this excerpt are probably the best description to be found of the drama and deep sensuality of the light of the South:

"A personal map, one like mine of Aix, has places on it which no printer could indicate, for they are clear only as a smell, or a sound, or a moment of light or dark.

"My whole map has a special smell, of course, apart from a few localized ones like the firm delicate fishiness on Fridays as I walked past the open-fronted stalls piled with seaweed and all the animals of the Mediterranean… or like the dark brown greasy smell of the foot-doctor's corridor… or the one in the olive oil shop. There is the Aix smell, made up of the best air I have ever breathed, purified by all the fountains and the tall trees and the stalls piled with sweet fresh vegetables in the open markets. I feel quite sure that if I could be

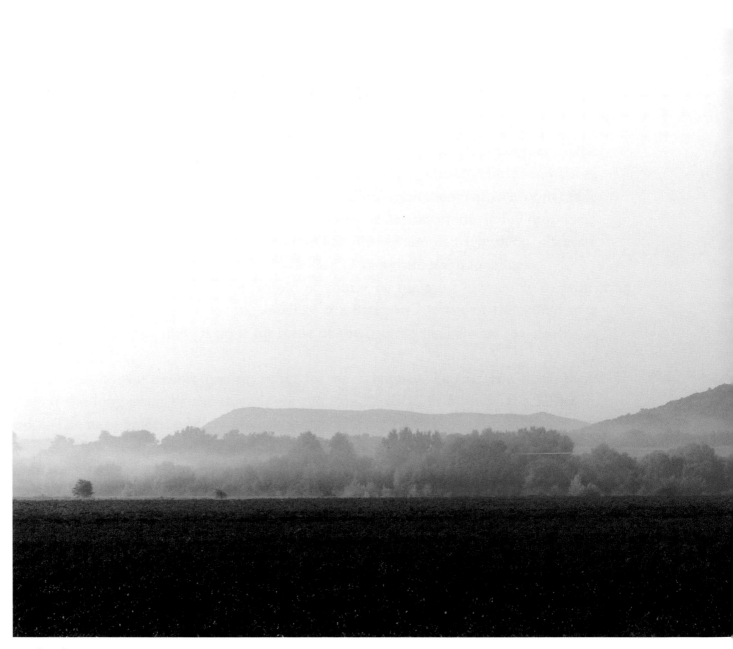

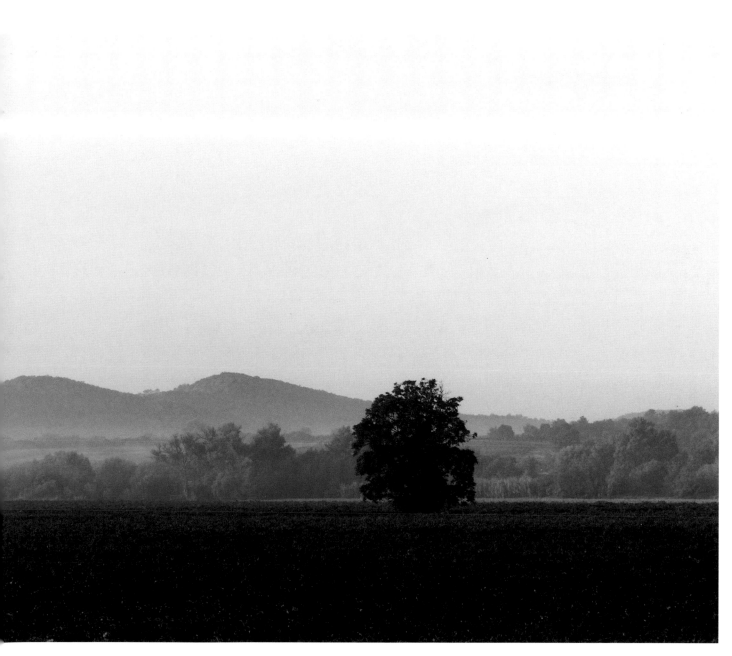

DAWN, NEAR QUISSAC

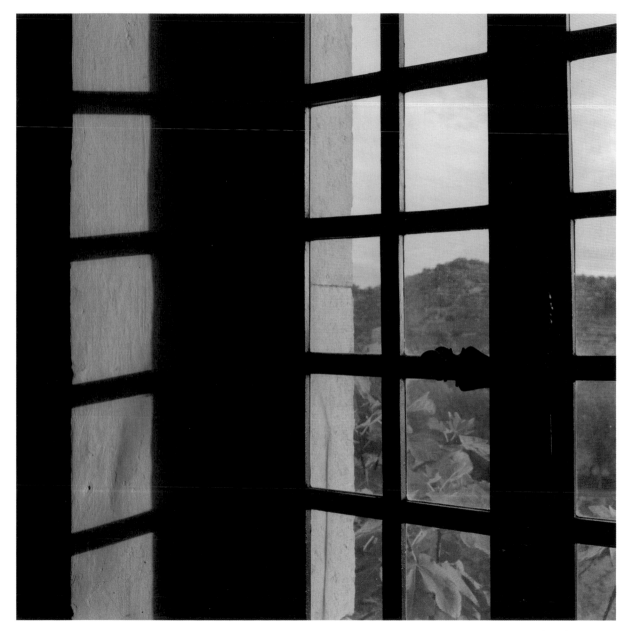

MORNING LIGHT AT THE LIBRARY WINDOW, BRISSAC-LE-HAUT { 33 }

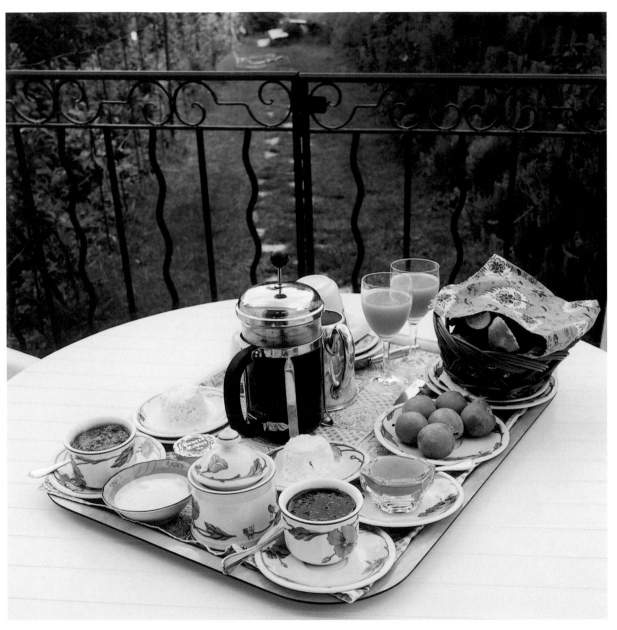

LE PETIT DÉJEUNER, VALENSOLE

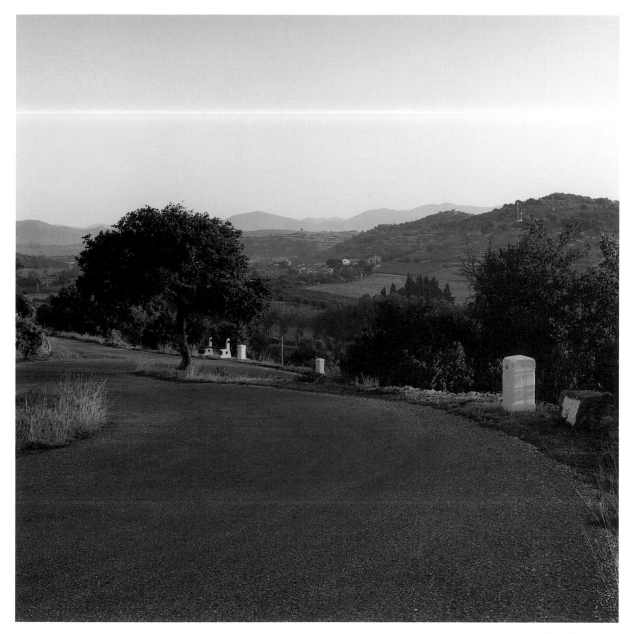

THE ROAD TO THE LOWER VILLAGE, BRISSAC-LE-HAUT {35}

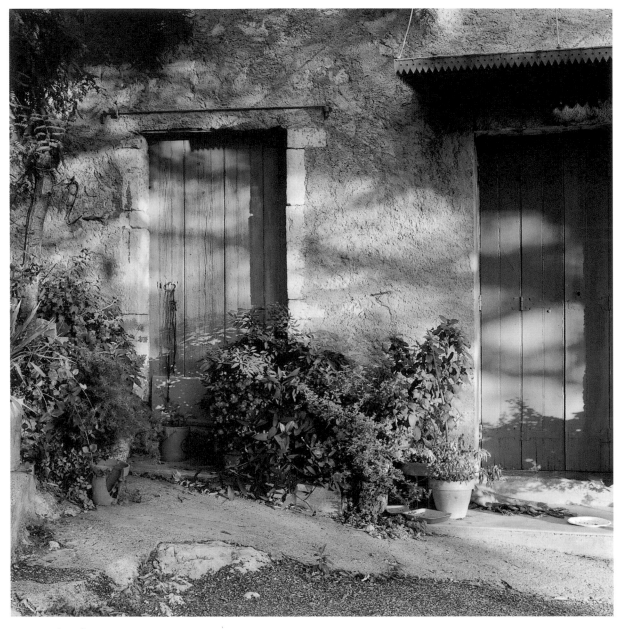

A DOORYARD IN BRISSAC-LE-HAUT

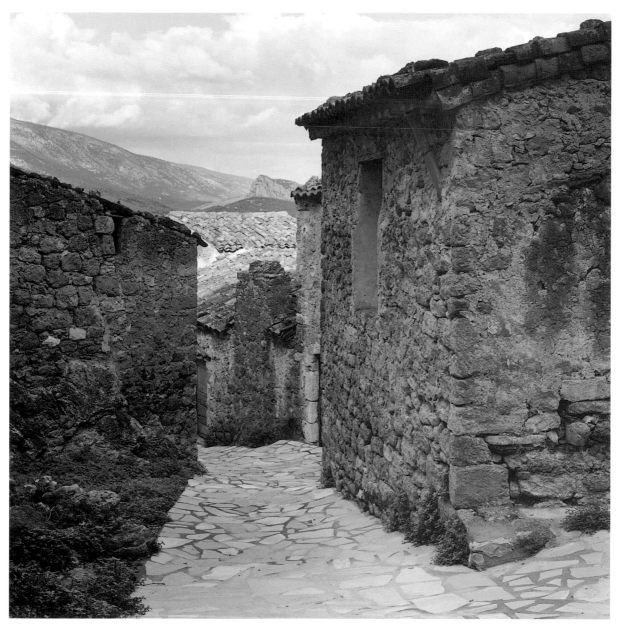

PATHWAY AMONG HOUSES, PÉGAIROLLES-DE-BUÈGES {39}

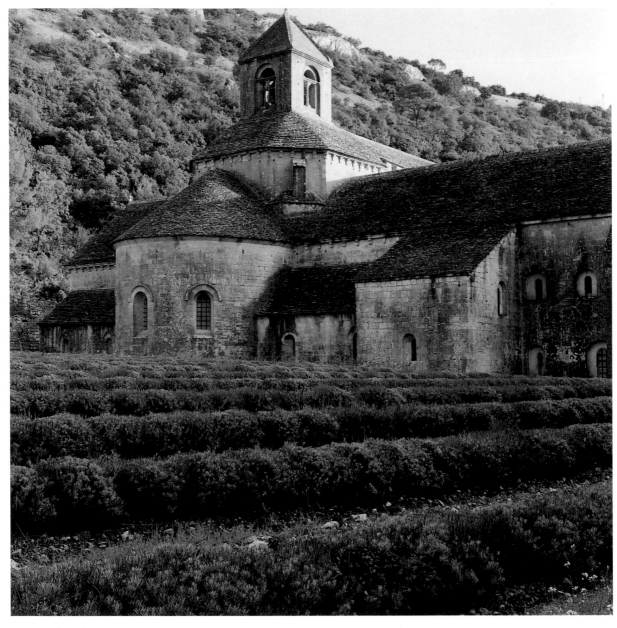

SÉNANQUE ABBEY, GORDES

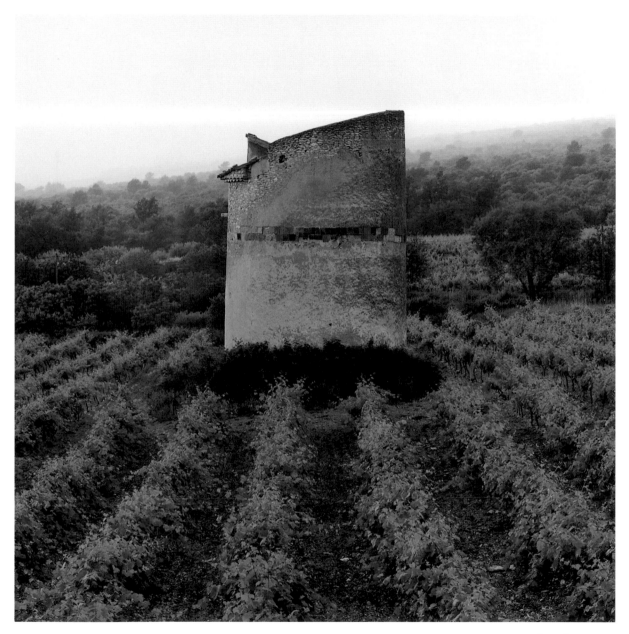

A PIGEON TOWER IN CROAGNES

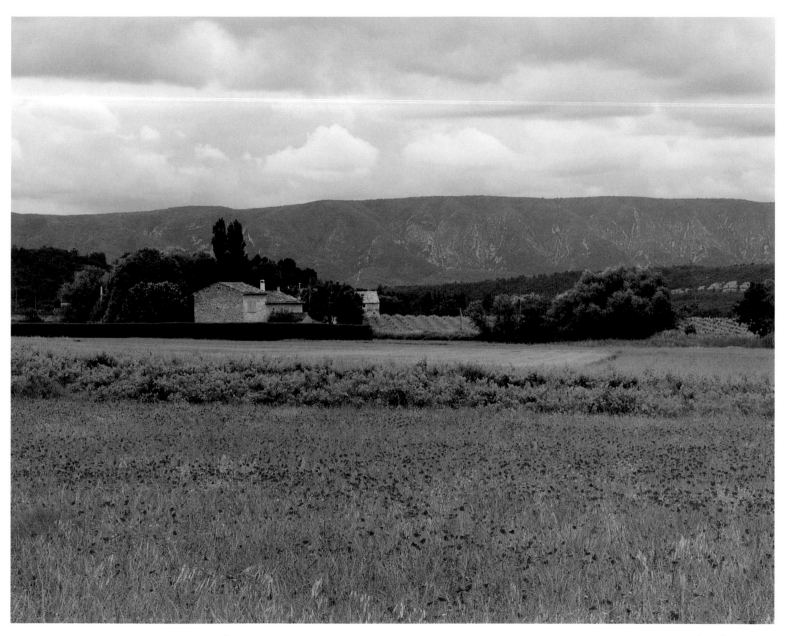

LANDSCAPE IN THE LUBÉRON

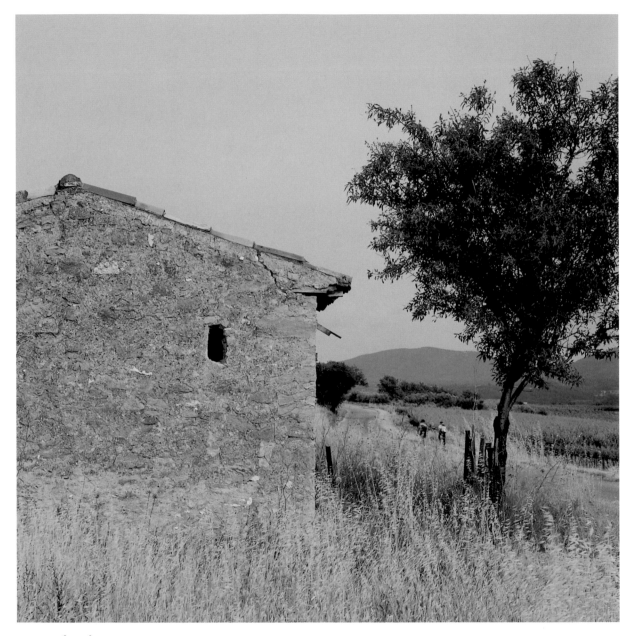

A ROAD NEAR AIX-EN-PROVENCE

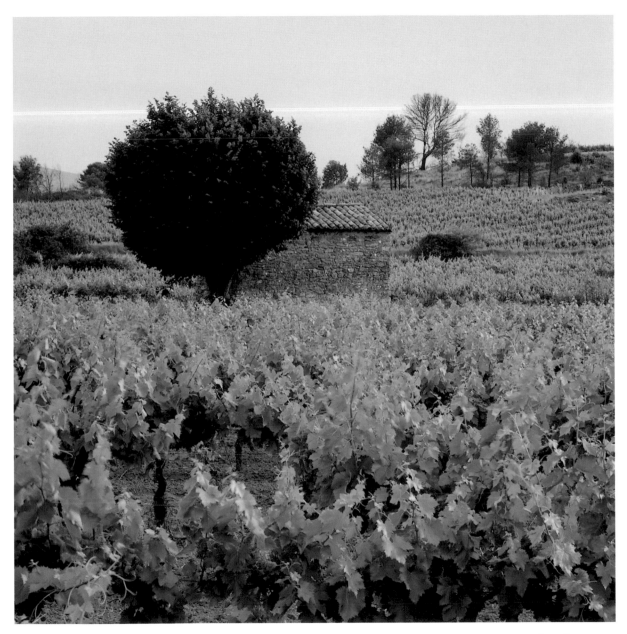

IN A VINEYARD NEAR AIX-EN-PROVENCE

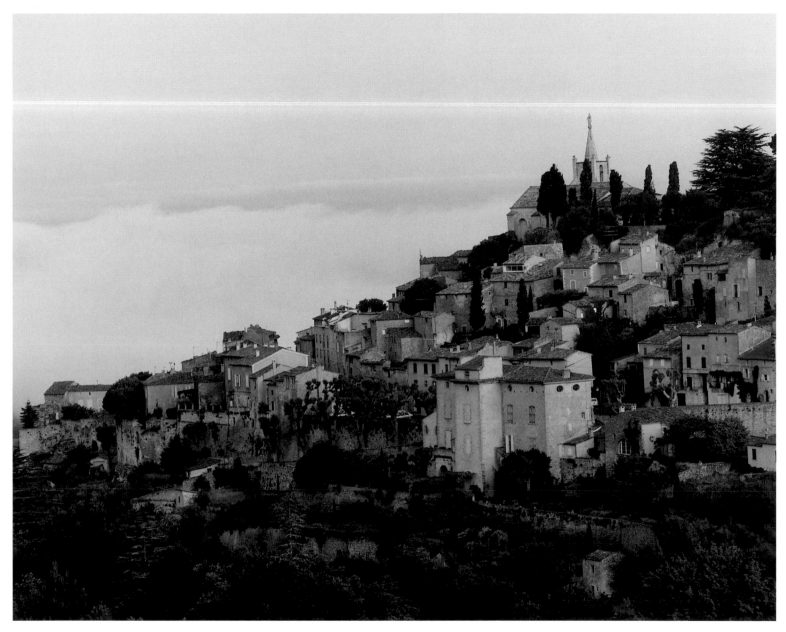

BONNIEUX, IN A SEA OF CLOUDS

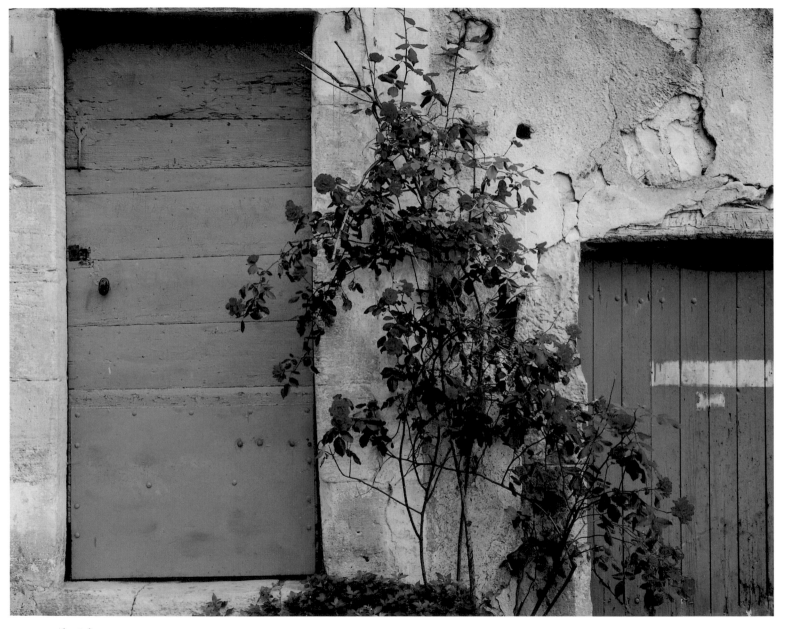

BLUE AND GREEN DOORS WITH CLIMBING ROSES, SAINT-MARTIN-DE-LONDRES

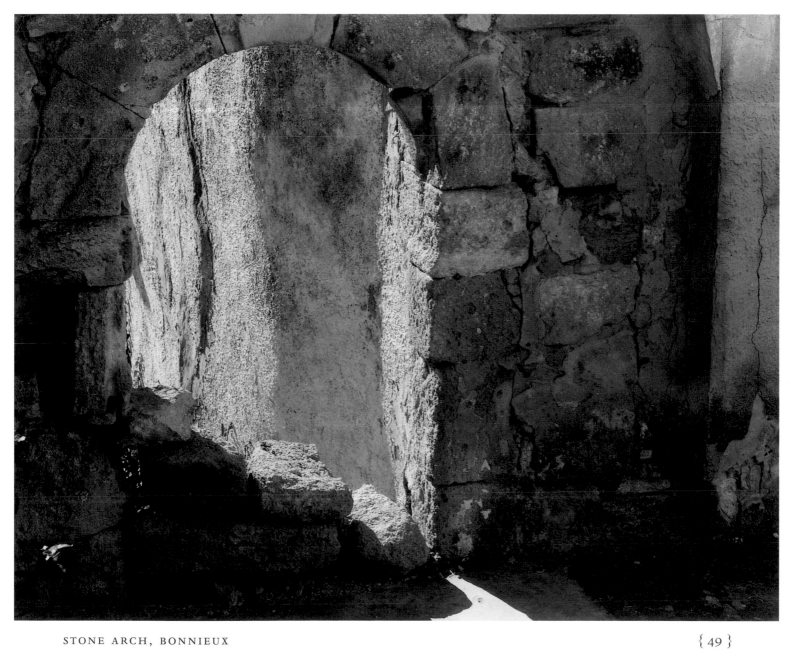

STONE ARCH, BONNIEUX

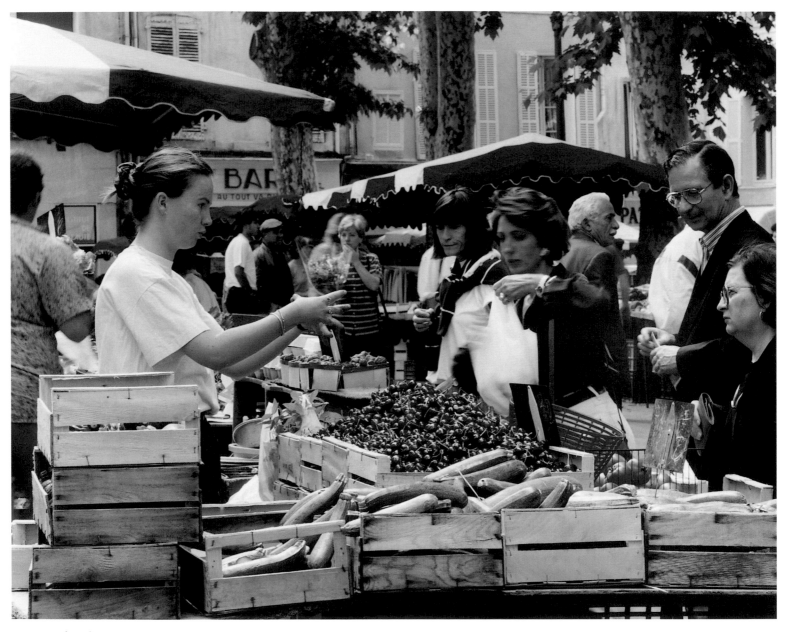

THE MORNING MARKET AT AIX-EN-PROVENCE

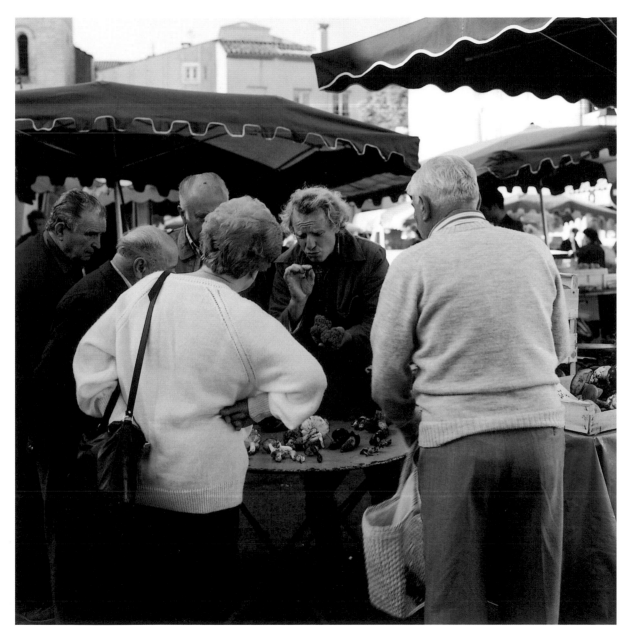

SELLING CÈPES AT THE GANGES MARKET

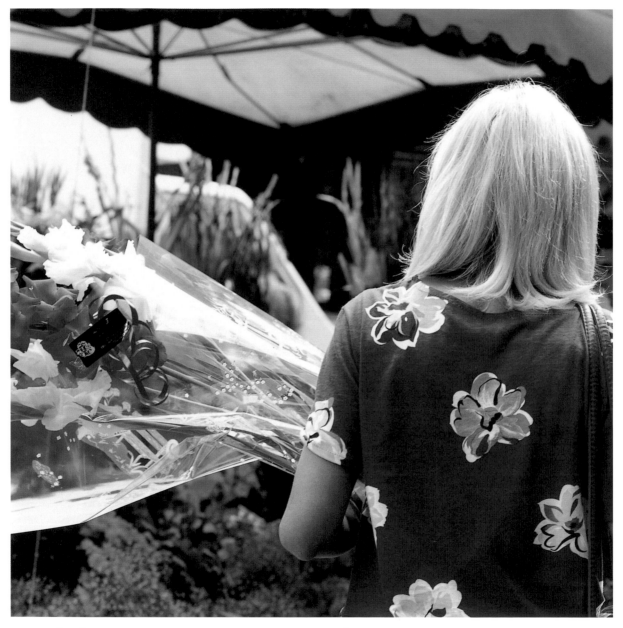

LE MARCHÉ AUX FLEURS, AIX-EN-PROVENCE

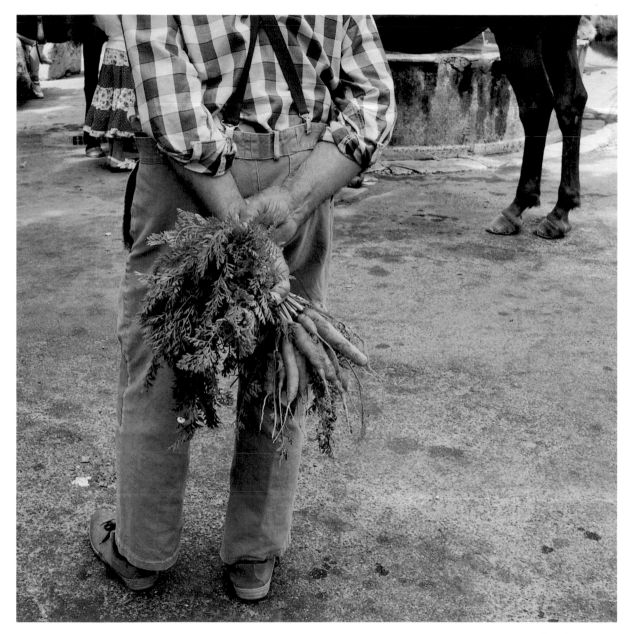

MAN HOLDING CARROTS, VARAGES

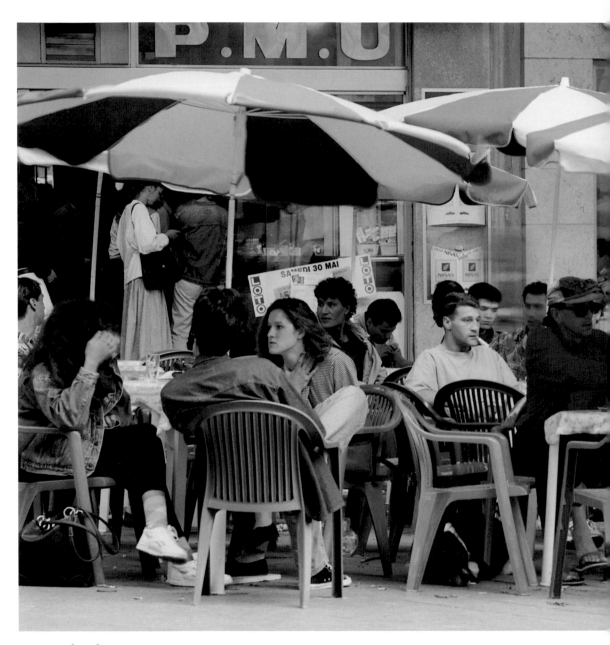

CAFÉ LIFE, AIX-EN-PROVENCE

ON COURS MIRABEAU, AIX-EN-PROVENCE

FLOWER SELLER, LE MARCHÉ AUX FLEURS, AIX-EN-PROVENCE {57}

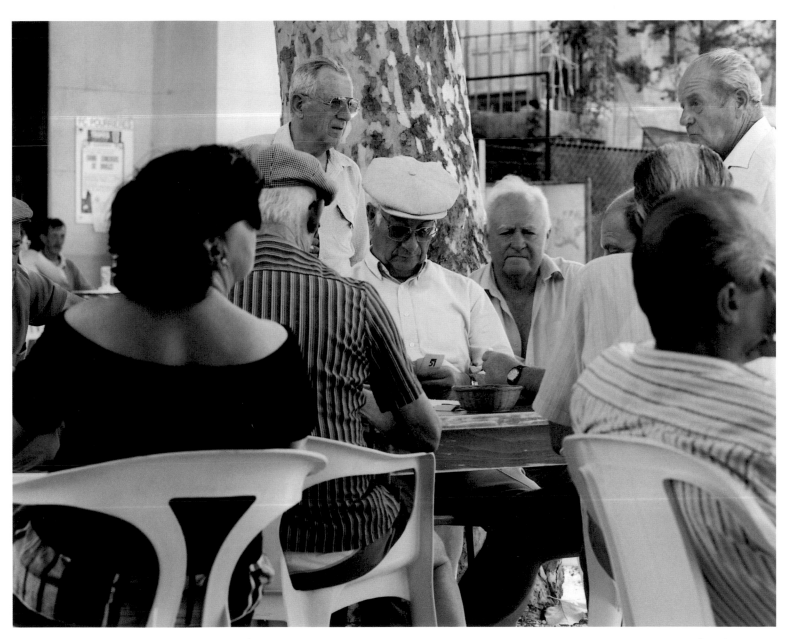

A GAME OF CARDS, POURRIÈRES

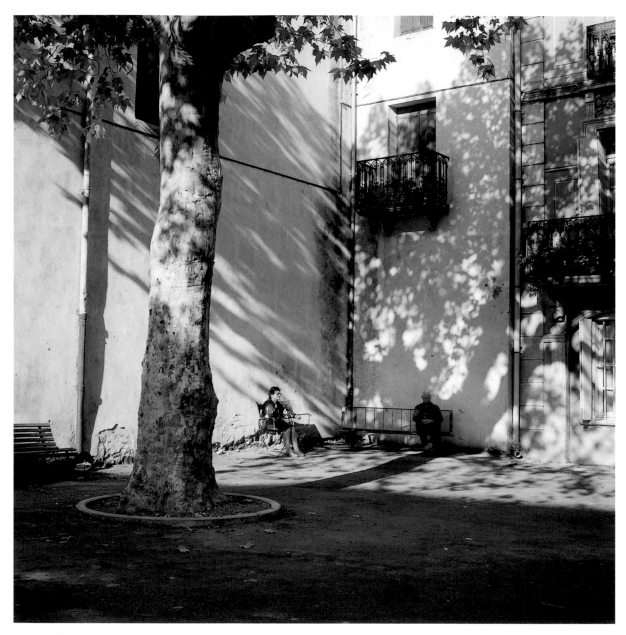

A WOMAN AND A MAN UNDER A PLANE TREE, SAUVE

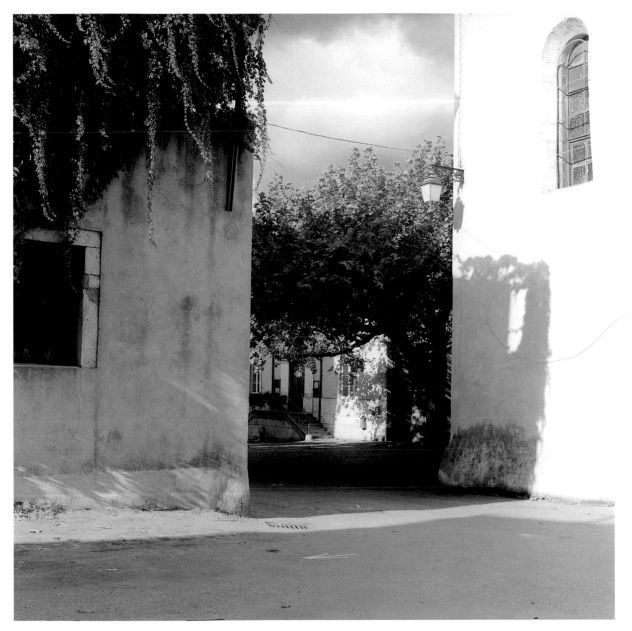

VIEW OFF THE SQUARE, SAUVE

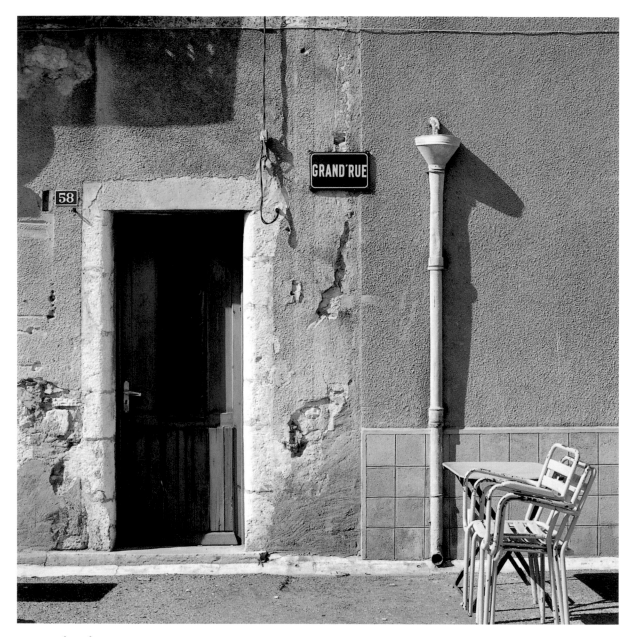

MAIN STREET, SAINT-BAUZILLE-DE-PUTOIS

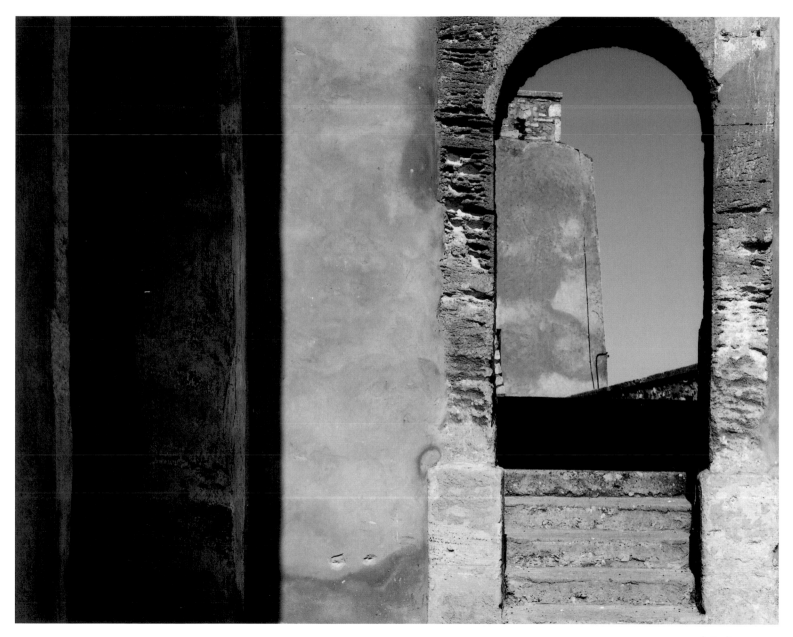

BLUE SKY AND ARCH, ROUSSILLON

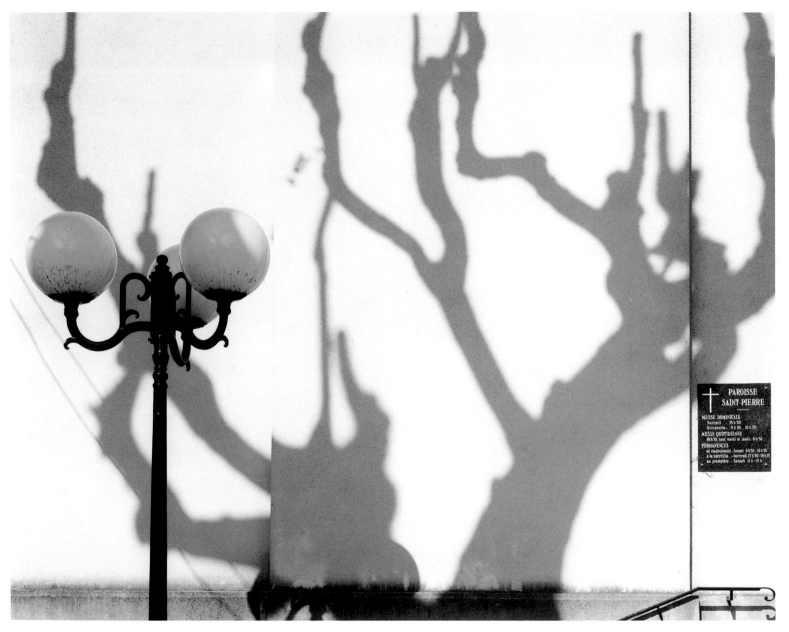

SHADOWS OF PLANE TREES ON A CHURCH WALL, LE VIGAN

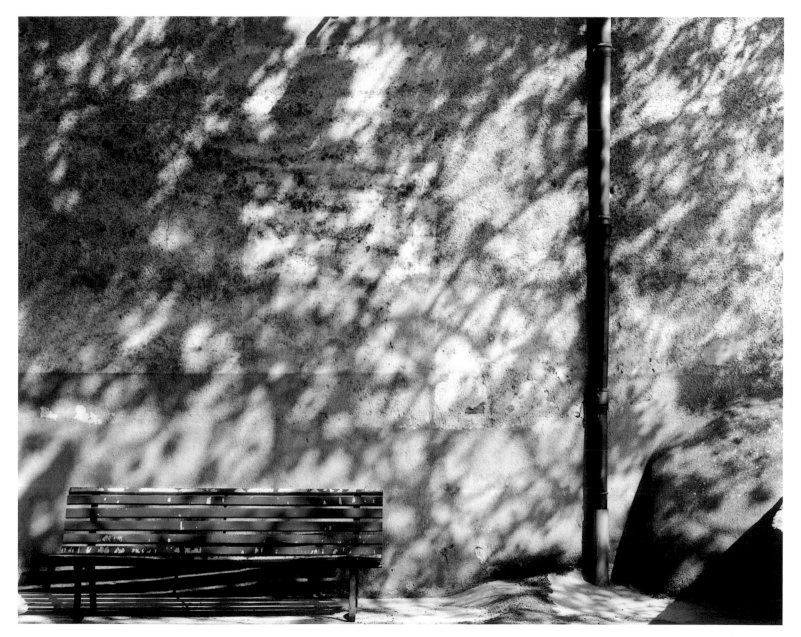

DAPPLED SUNLIGHT AND GREEN BENCH, SAUVE

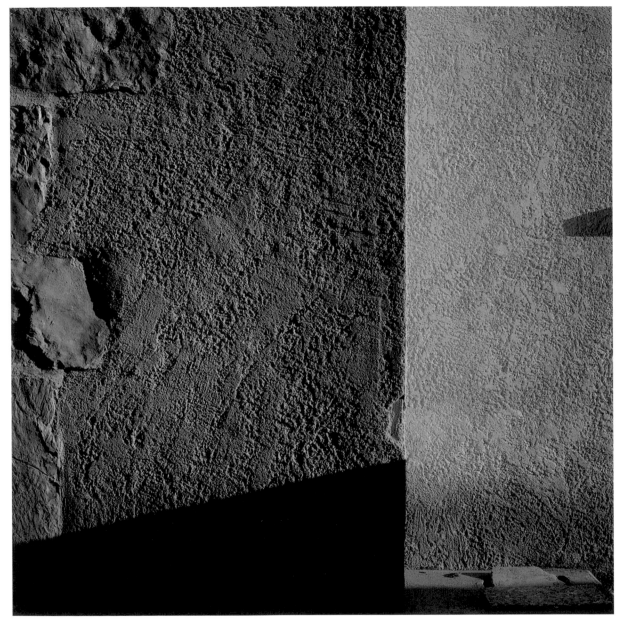

{ 66 } FRENCH LIGHT, PÉGAIROLLES-DE-BUÈGES

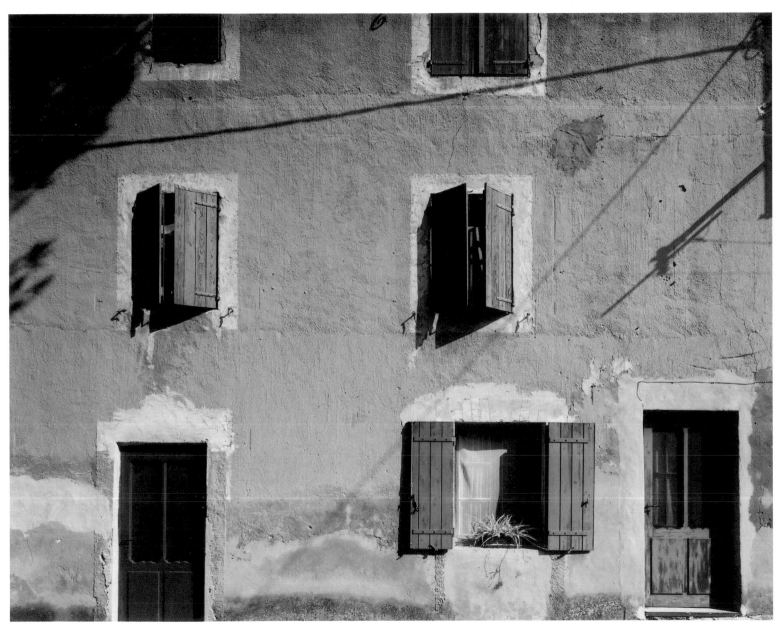

YELLOW WALL WITH GREEN SHUTTERS, ROUSSILLON

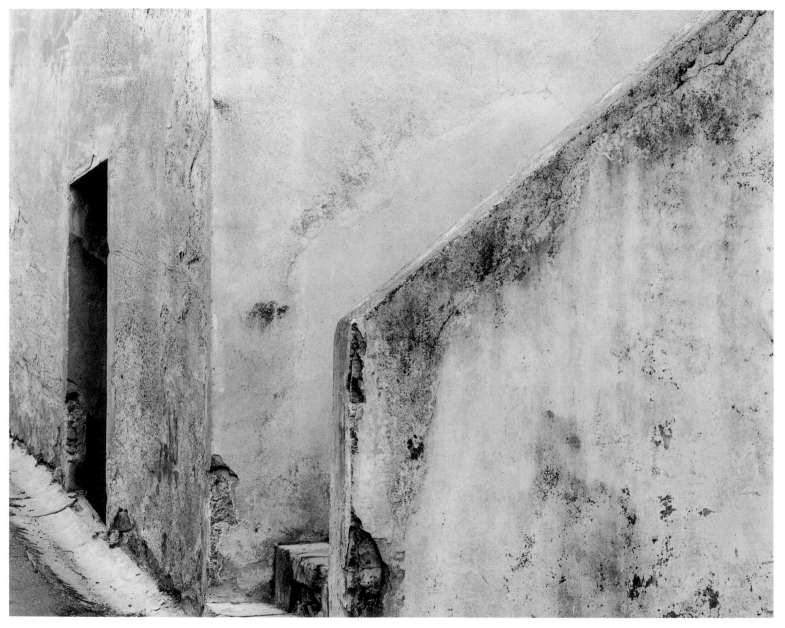

A PASSAGE IN SUMÈNE, VIEW NO. I

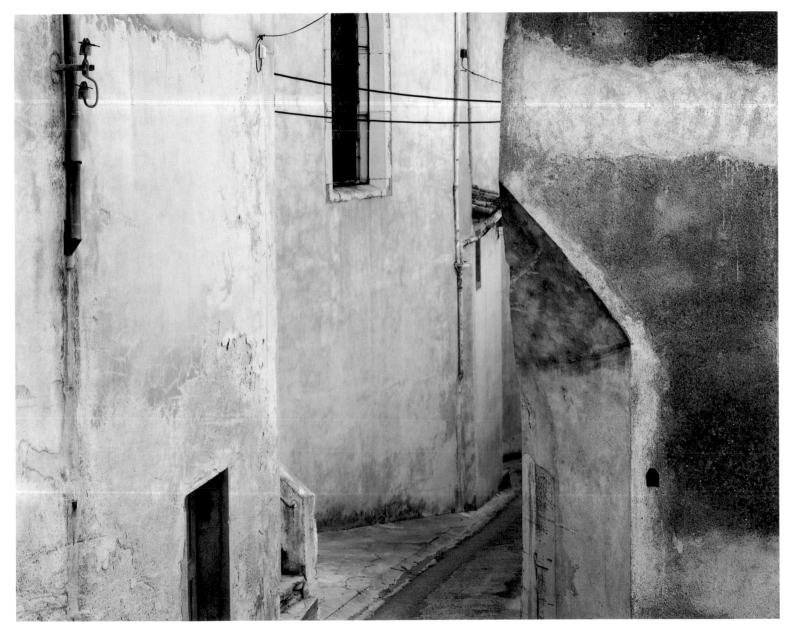

A PASSAGE IN SUMÈNE, VIEW NO. 2

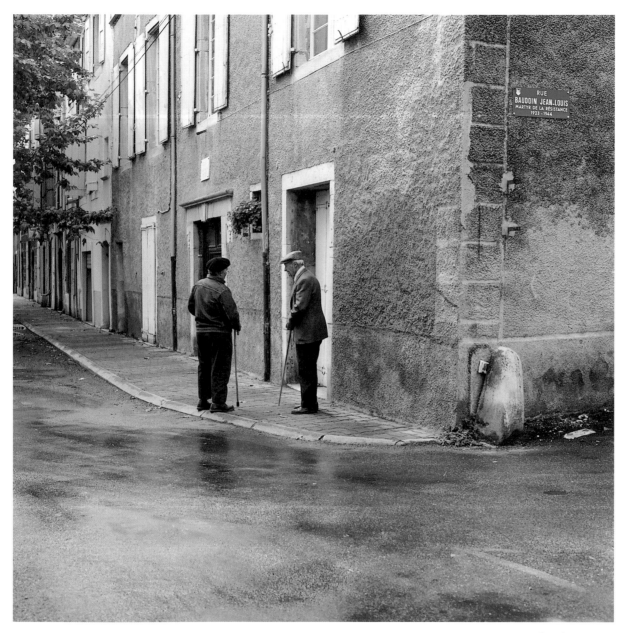

TWO MEN WITH CANES, SAINT-HIPPOLYTE-DU-FORT {71}

WALL STUDY WITH GREEN IRONWORK, ROUSSILLON

ANCIENT MULBERRY TREE, SAINT-PANTALÉON {73}

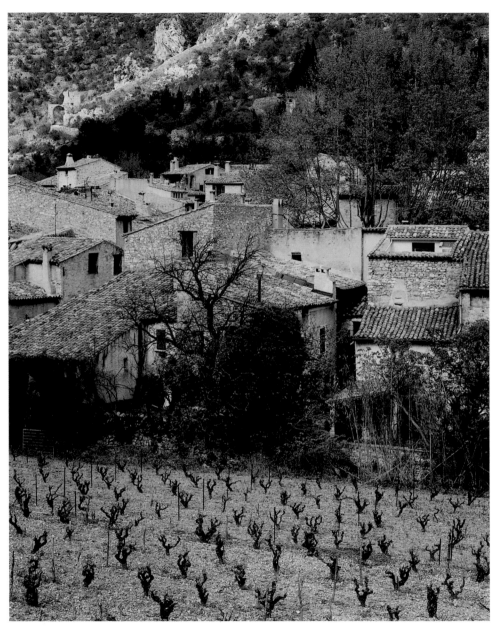

VIEW OF SAINT-GUILHEM-LE-DÉSERT

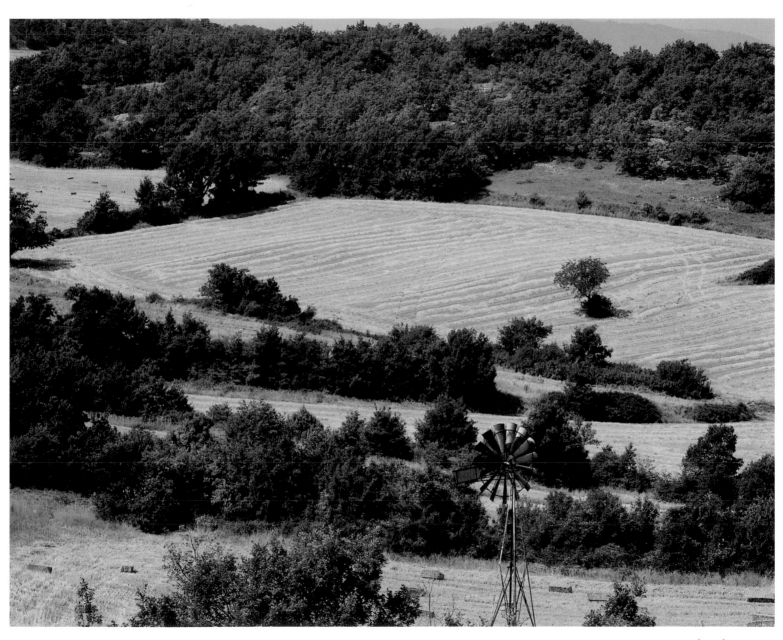

FIELDS WITH A WINDMILL, VILLEMUS

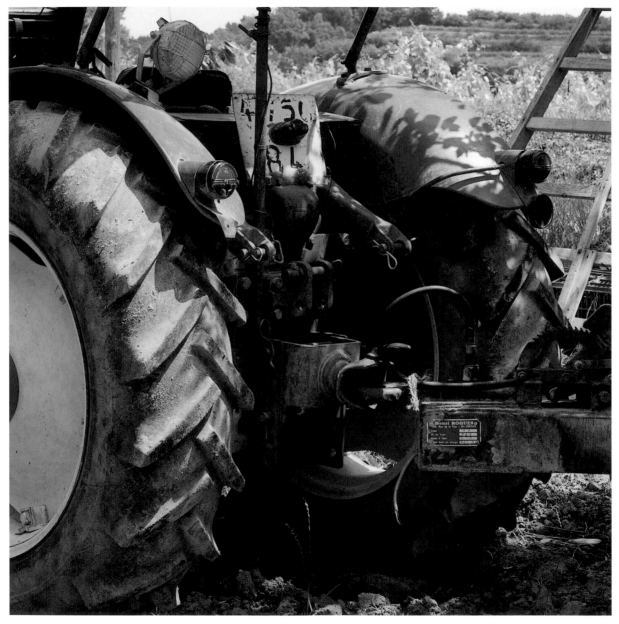

TRACTOR, NEAR LA TOUR D'AIGUES

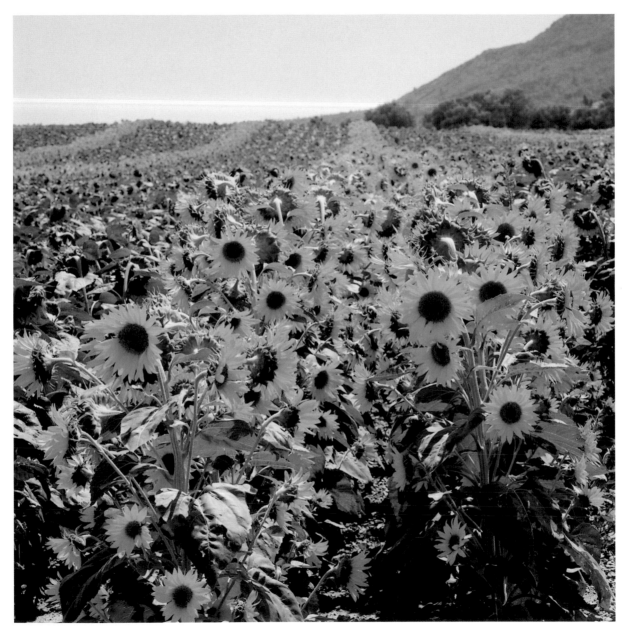

SUNFLOWER FIELD, ARTIGUES

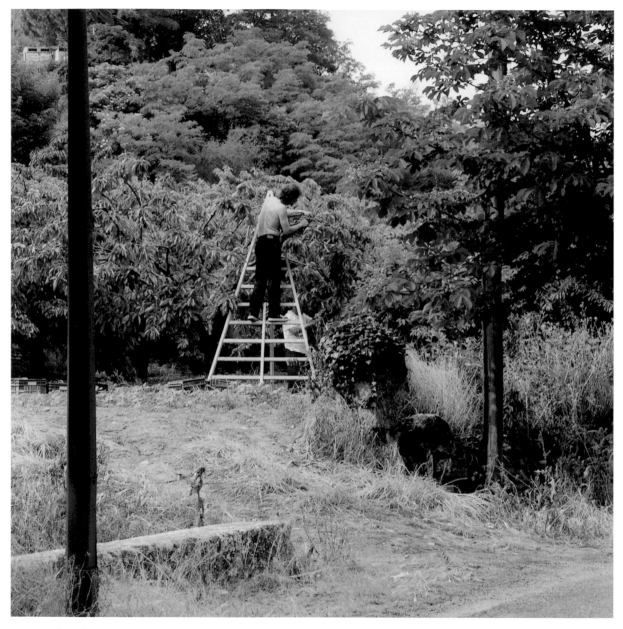

CHERRY PICKERS, NEAR BONNIEUX

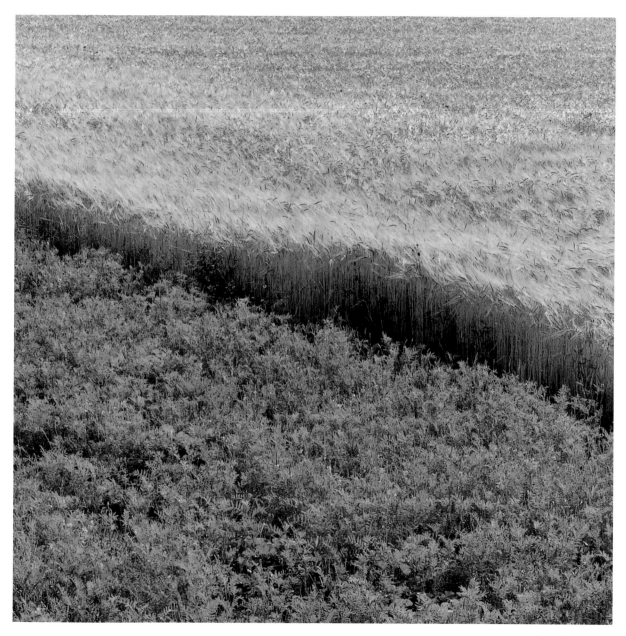

IN A FIELD NEAR SAIGNON

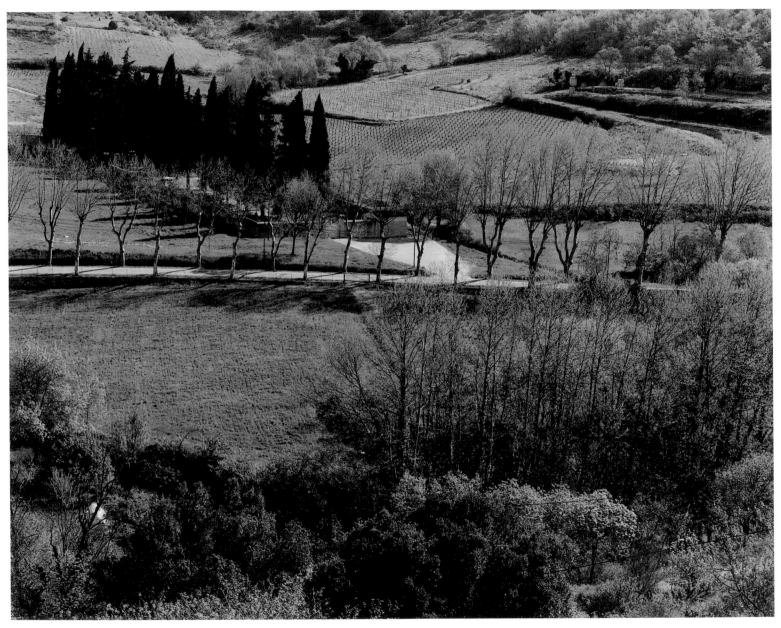

A VIEW FROM BRISSAC-LE-HAUT

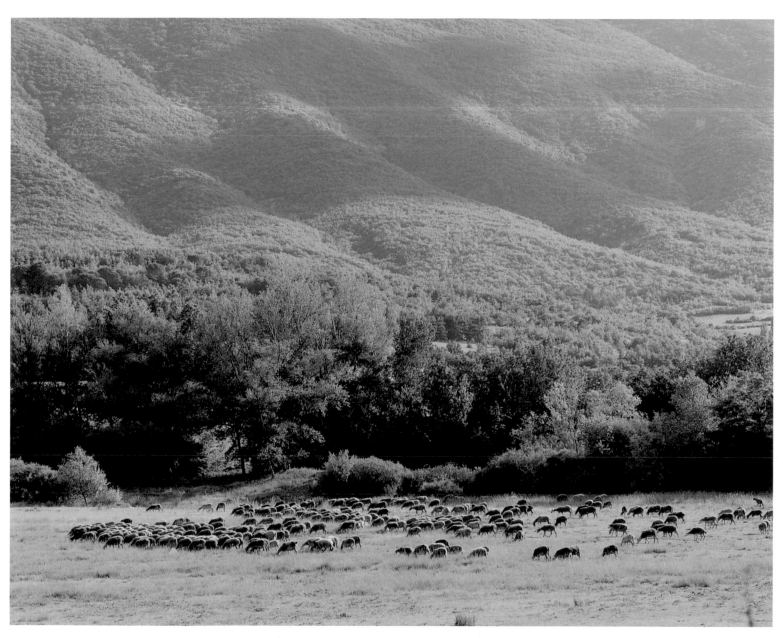

SHEEP BELOW A HILLSIDE, LA BÉGUDE

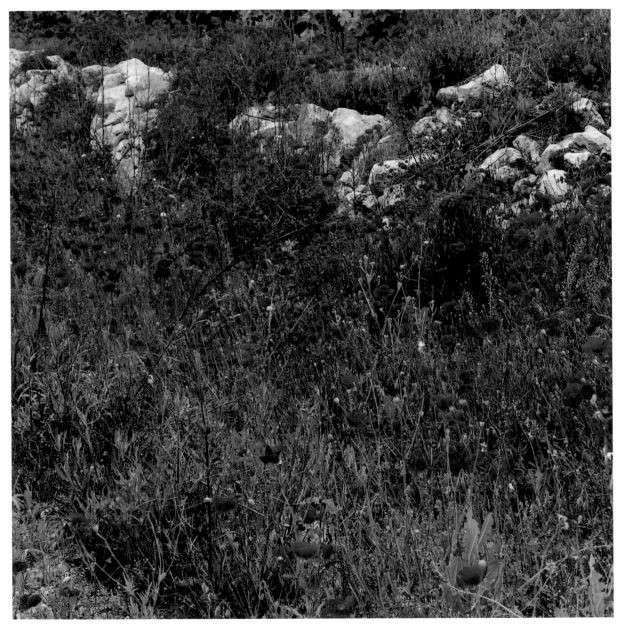

POPPIES BY AN OLD WALL, MÉNERBES

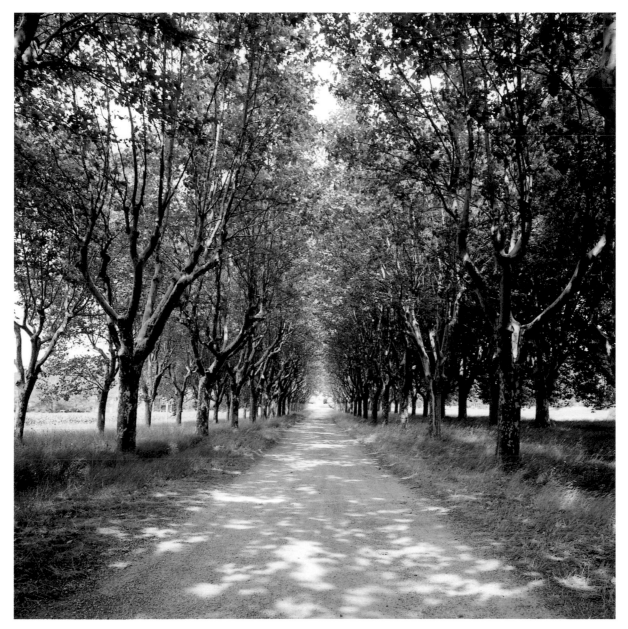

L'ALLÉE, RIANS

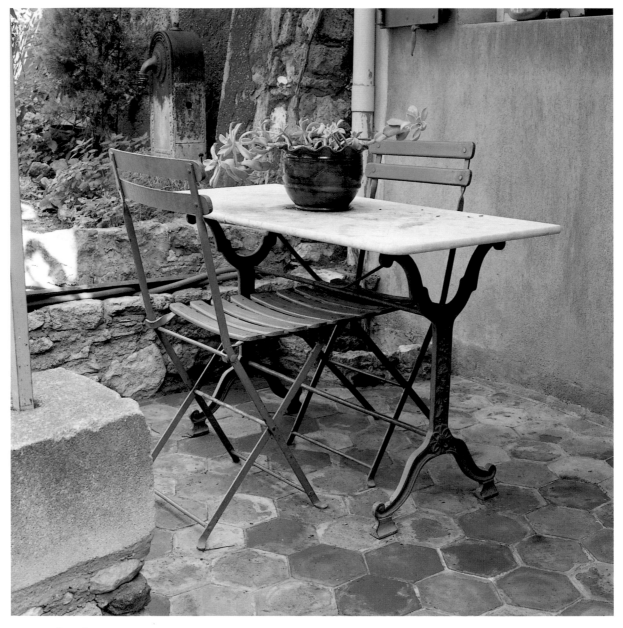

TABLE AND CHAIRS, ROUSSILLON

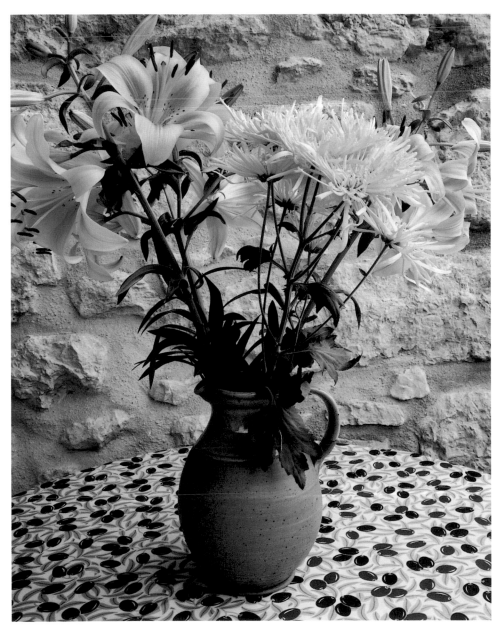

STILL LIFE WITH YELLOW FLOWERS, BRISSAC-LE-HAUT

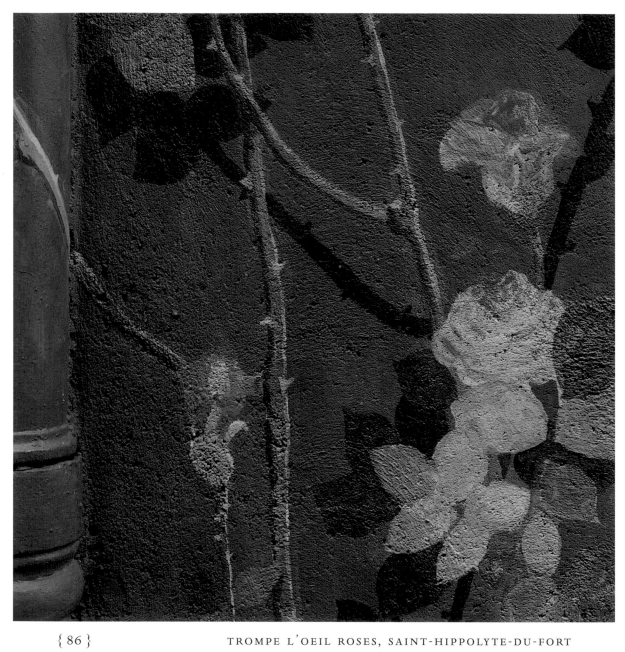

TROMPE L'OEIL ROSES, SAINT-HIPPOLYTE-DU-FORT

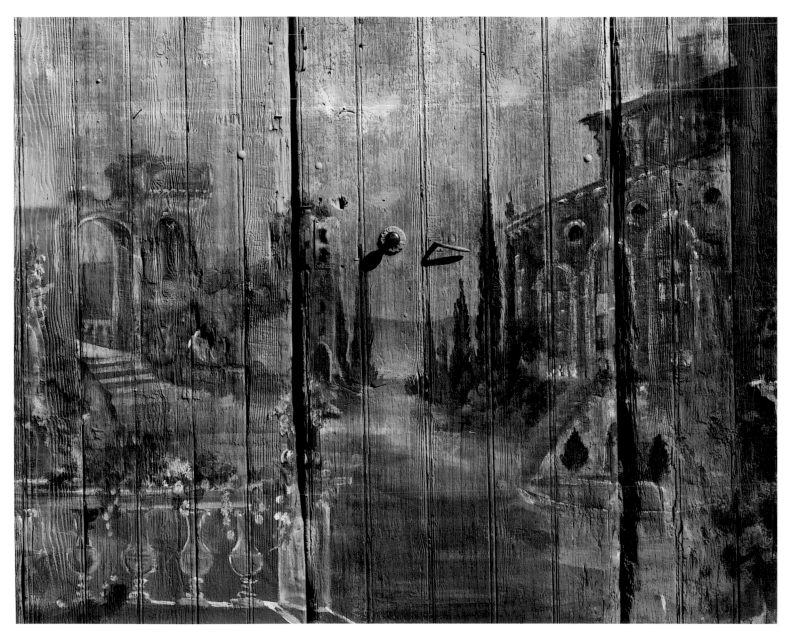

TROMPE L'OEIL LANDSCAPE, ROUSSILLON

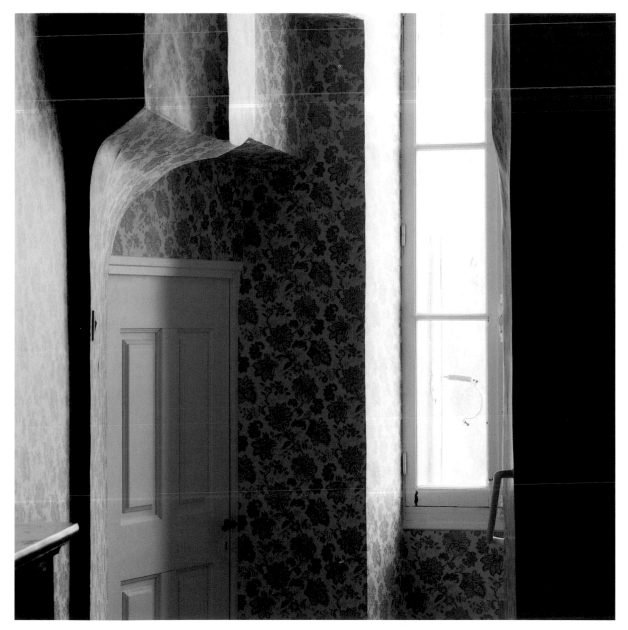

WALLPAPERED HALLWAY, BONNIEUX {89}

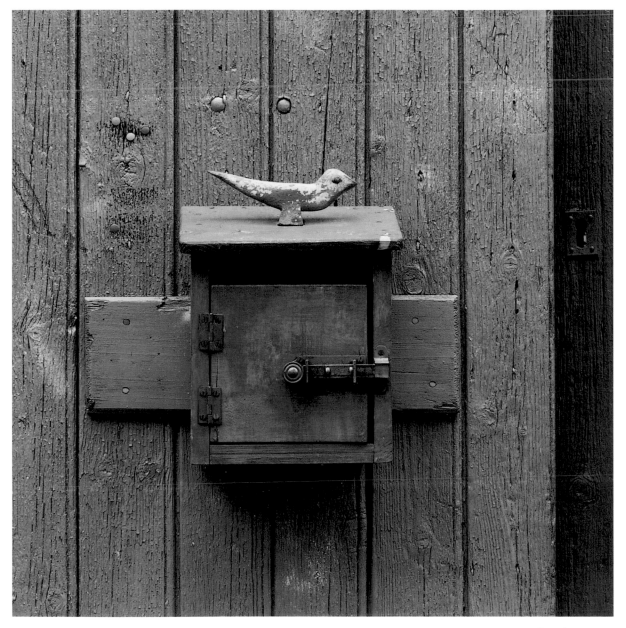

MAILBOX, MÉNERBES

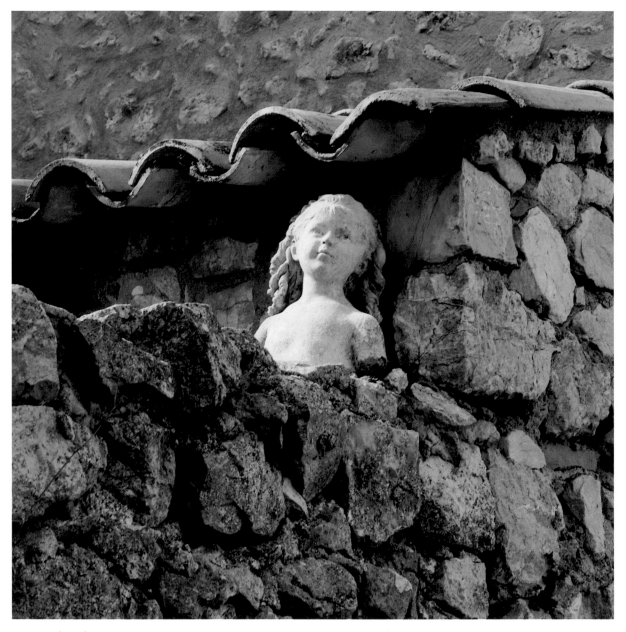

SCULPTURE OF A GIRL, FOX-AMPHOUX

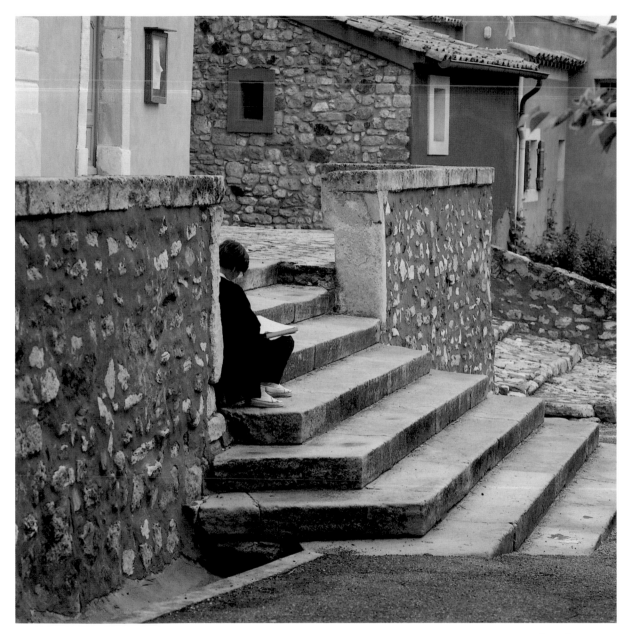

WOMAN SKETCHING, ROUSSILLON

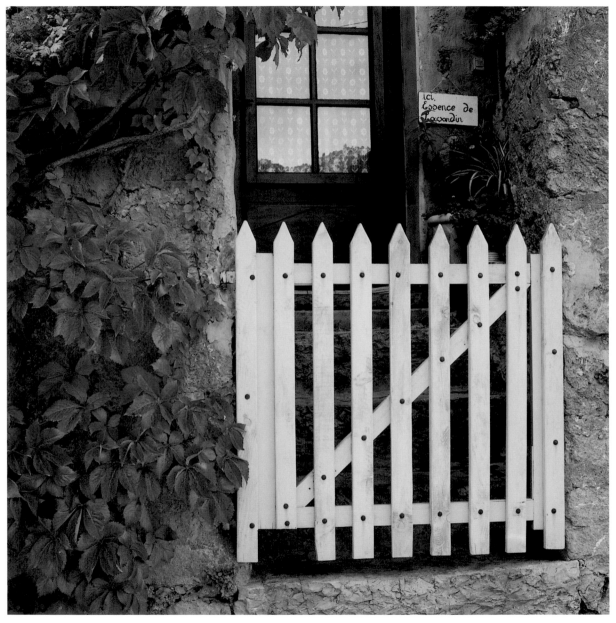

A DOORWAY IN PÉGAIROLLES-DE-BUÈGES

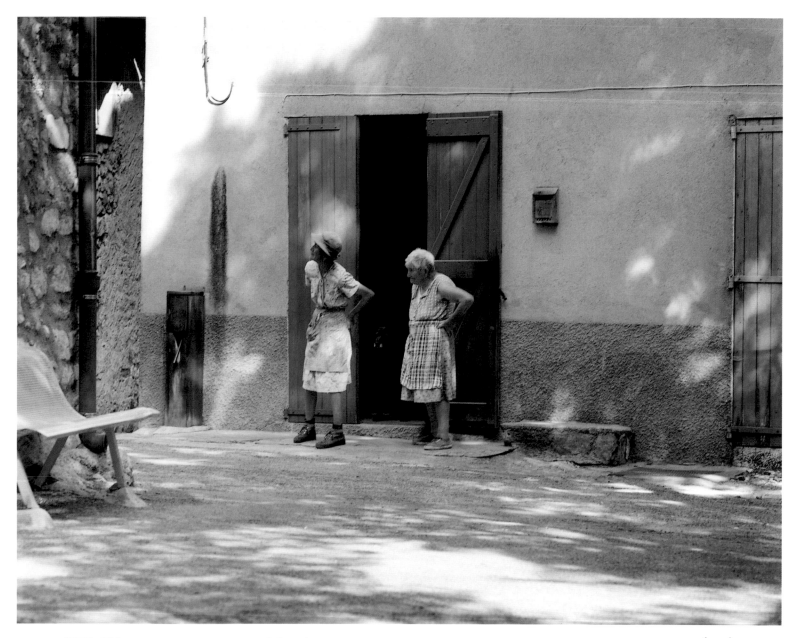

TWO WOMEN AND A BLACK DOG, FOX-AMPHOUX

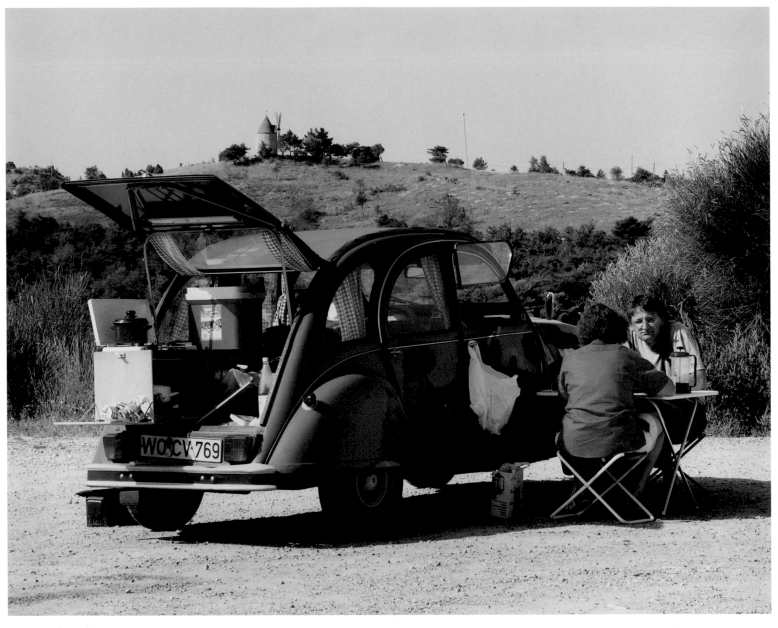

LE PIQUE-NIQUE, MONTFURON

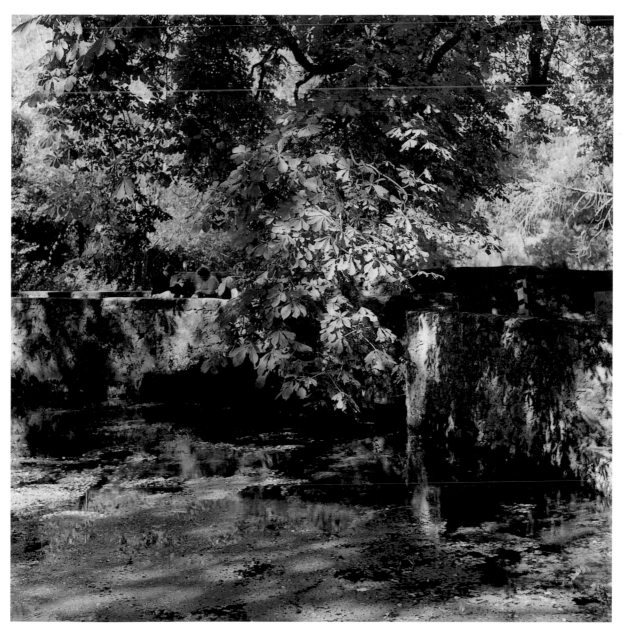

THE BRIDGE IN THE PARK, BRISSAC {97}

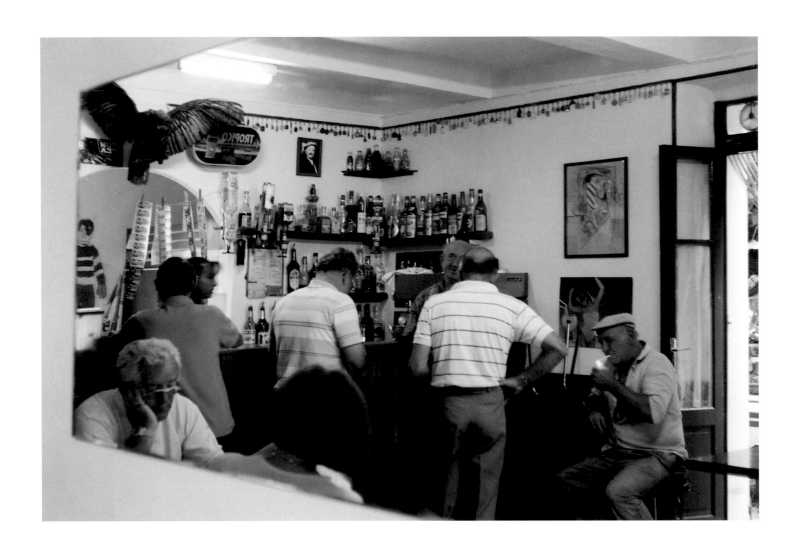

A BAR IN FOX-AMPHOUX

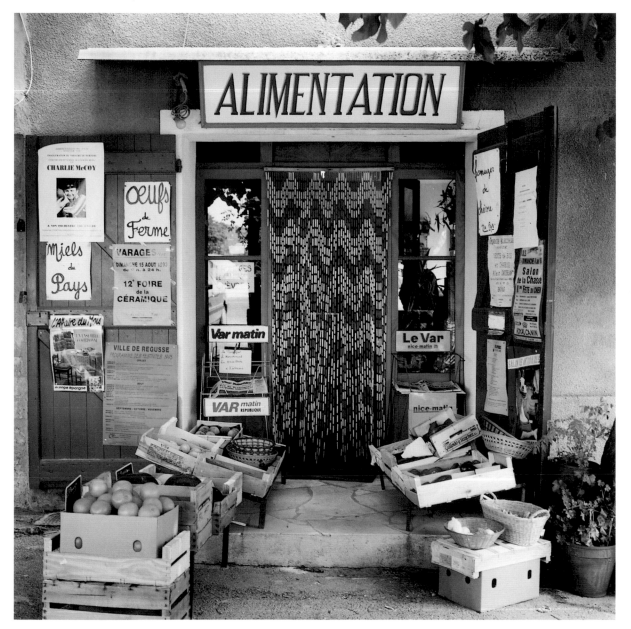

ALIMENTATION, FOX-AMPHOUX

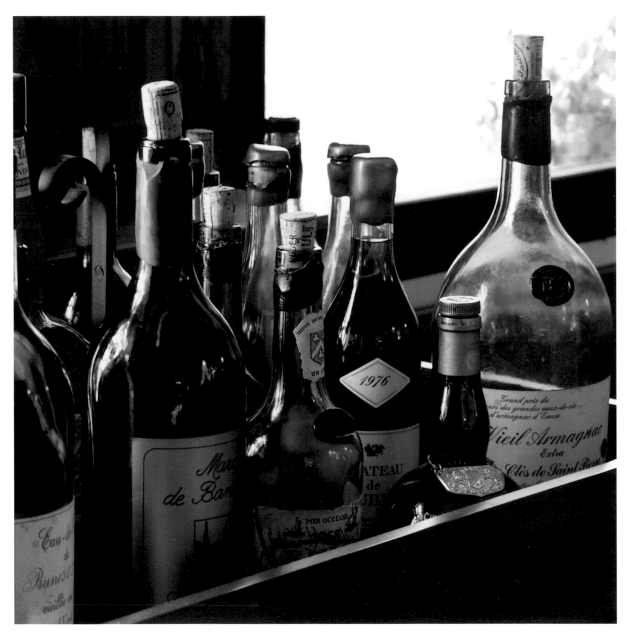

DINING ROOM STILL LIFE, BEAURECUEIL

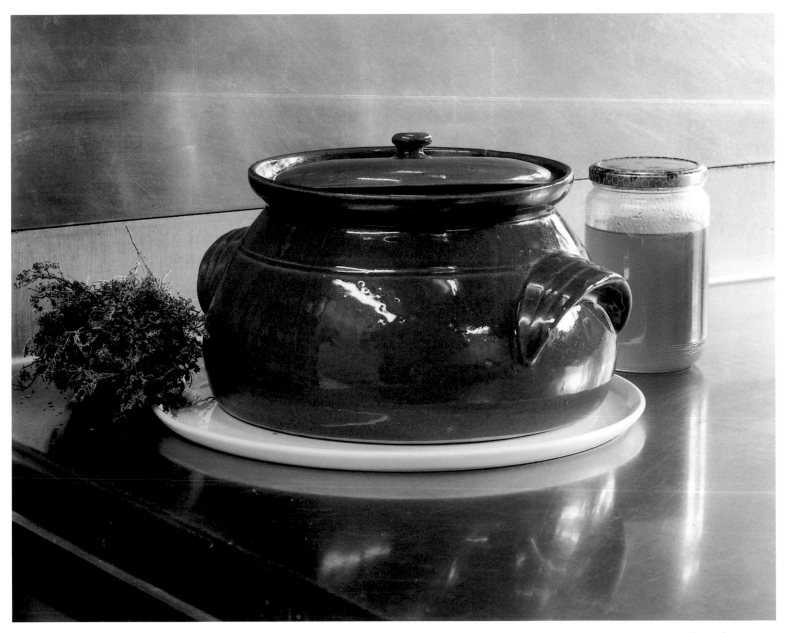

KITCHEN STILL LIFE, BEAURECUEIL

THE PROPRIETRESS, BEAURECUEIL

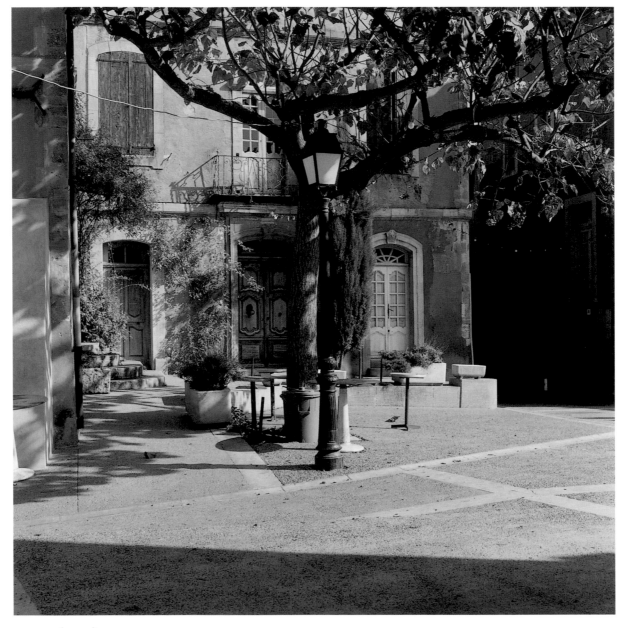

THE SQUARE, ROUSSILLON

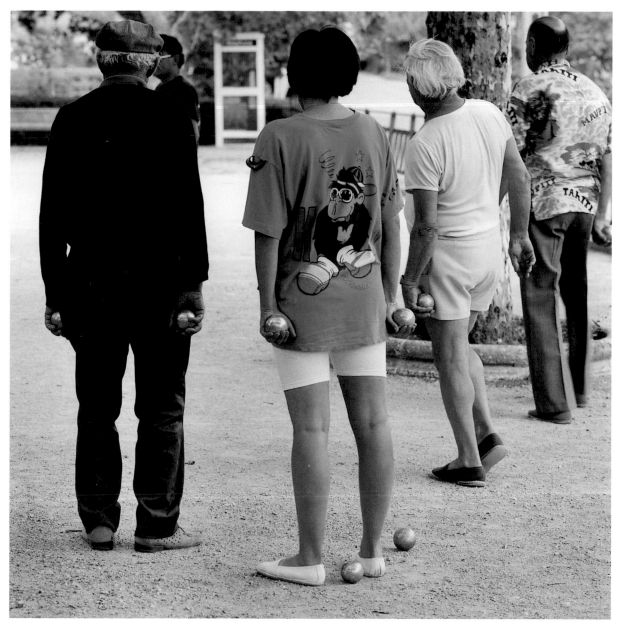

PÉTANQUE, PUYLOUBIER

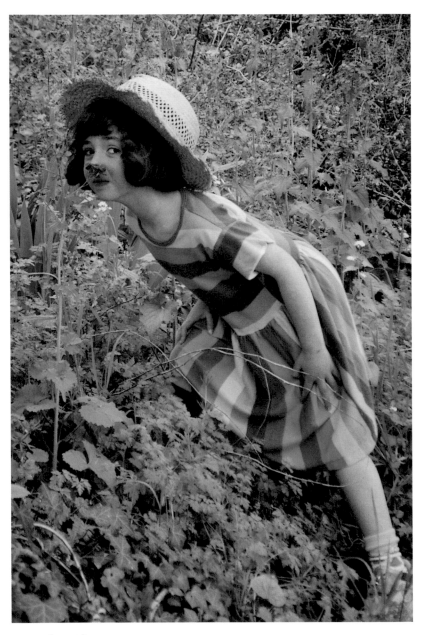

IN THE GARDEN, BRISSAC-LE-HAUT

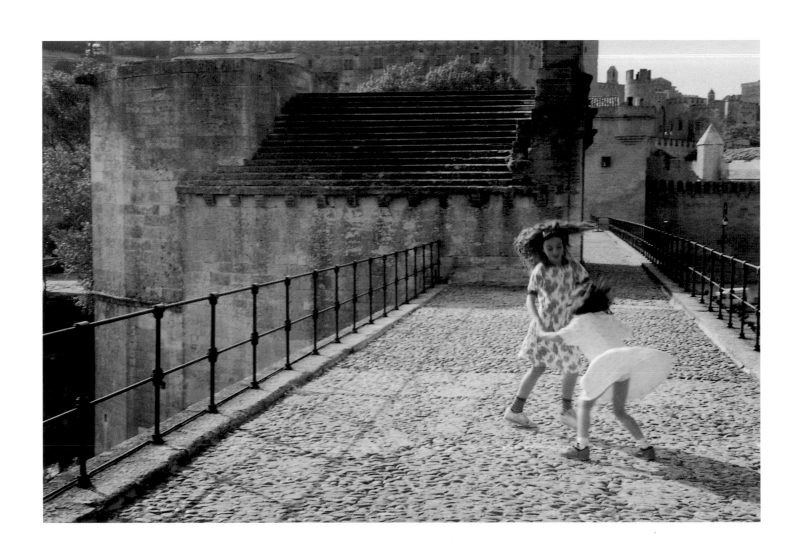

"SUR LE PONT D'AVIGNON, ON Y DANSE…" (PONT SAINT-BÉNÉZET) {107}

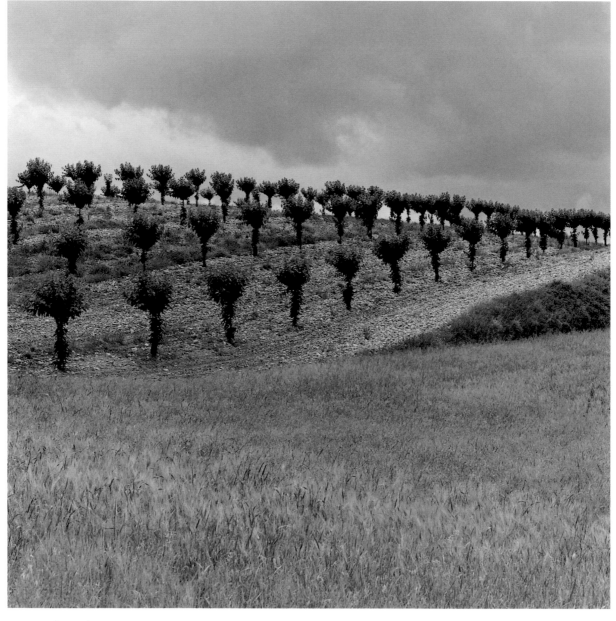

CHERRY TREES AND POPPIES, NEAR MURS

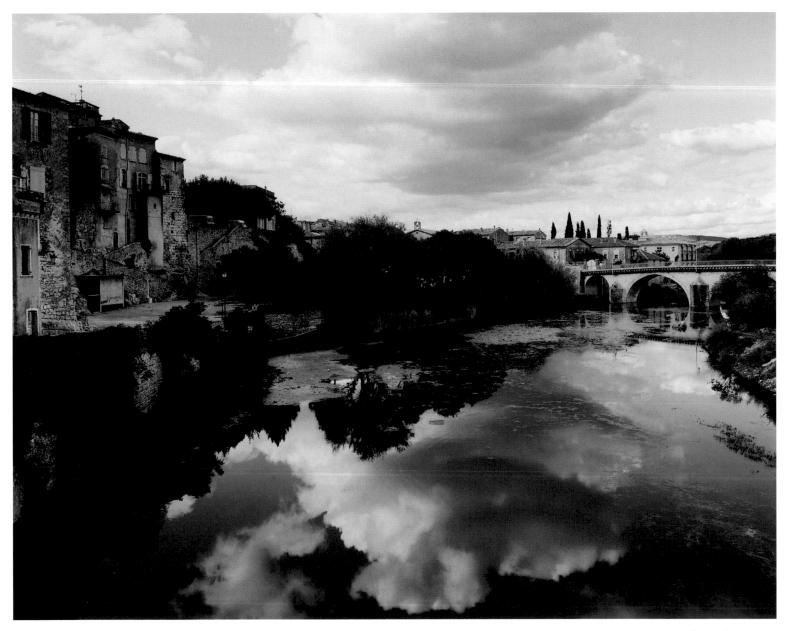

THE VIDOURLE RIVER AT SAUVE

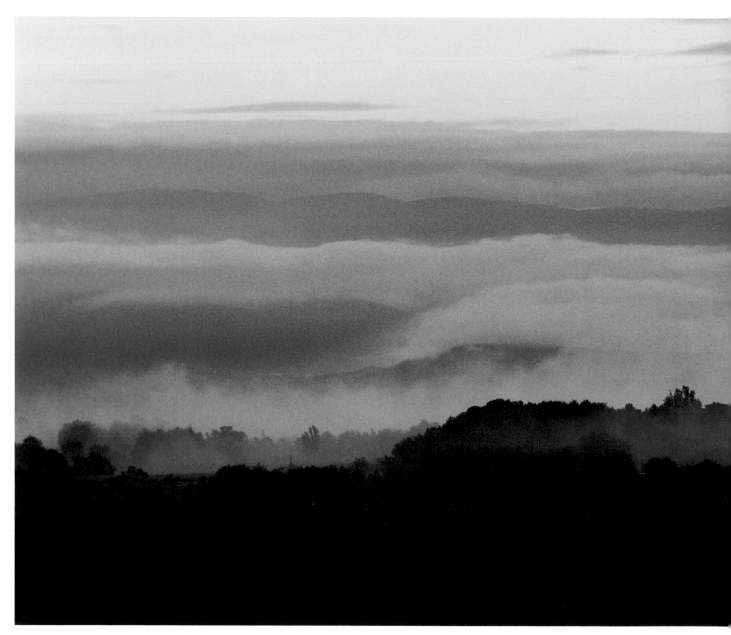

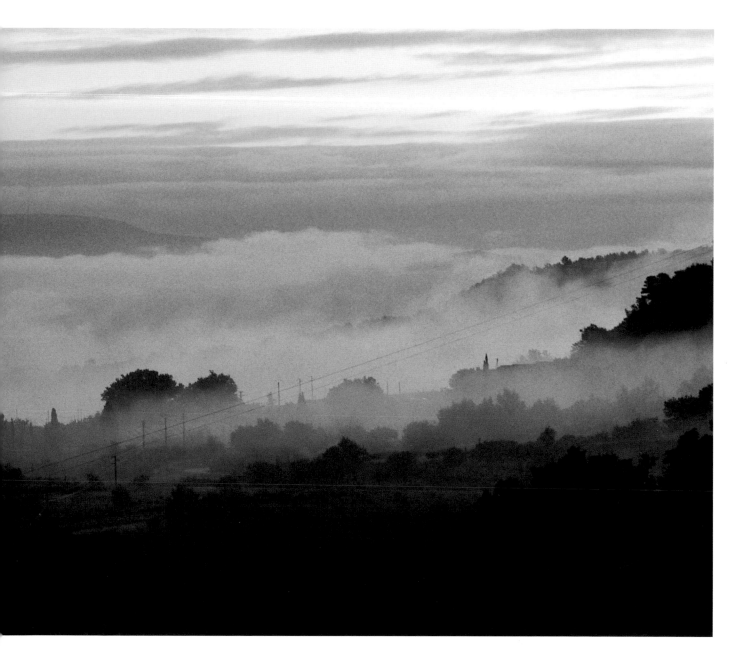

A VIEW FROM BONNIEUX

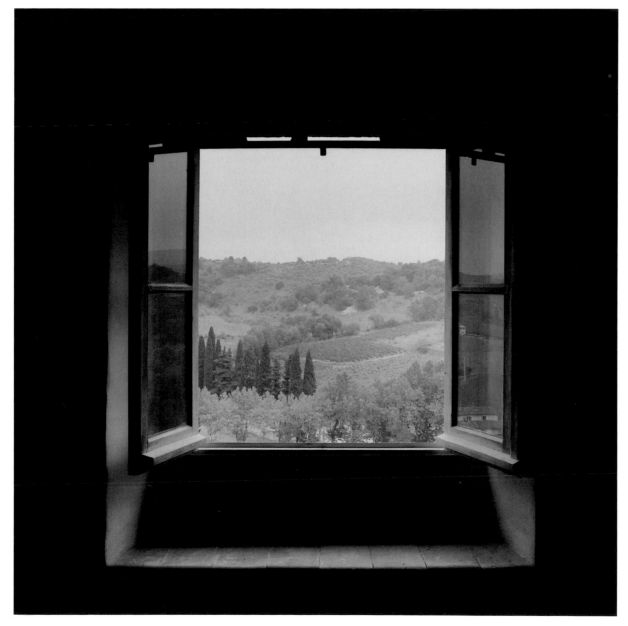

THE STUDIO WINDOW, BRISSAC-LE-HAUT

List of Photographs

✦

About the Author

DON KROHN was born in New York City in 1949. A graduate of Brandeis University and Harvard Law School, he has also studied in the Committee on Social Thought at the University of Chicago. He has taught photography and has lectured on law at University College in Cork, Ireland. His diverse travels have included treks in Nepal, as well as long sojourns in Ireland and France. On Cape Cod, where he resides with his family, he has been active in civic affairs and preservation efforts. He is the proprietor of the Orleans Whole Food Store and was the founding president of the Cape Cod Lighthouse Charter School. As a child, Krohn began taking photographs and working in the darkroom. Over the years, he has explored numerous aspects of the medium. Key influences on his artistic career have been the photographers Eugène Atget, Edward Weston, and Henri Cartier-Bresson.

In the South of France

was set in Monotype Dante, a digitized version of the typeface first cut in 1954 by the scholar-printer Giovanni Mardersteig. The original matrices were engraved by the Parisian punchcutter Charles Malin in the 12-point size; the design was later made widely available on the Monotype composing machines. With its Renaissance forms and stresses, its elegant and lively italic (one that derives from the designs of Aldus Manutius), and its sparkling cutting, Dante has continued to be a favorite of book designers.

In the South of France was designed
by Mark Polizzotti.